Menor

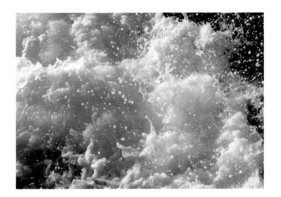

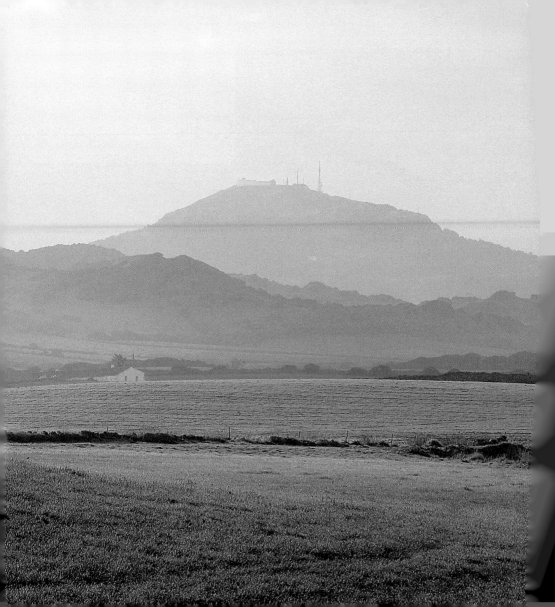

Menorca

Text
JOAN F. LÓPEZ CASASNOVAS

Photographs
**JAUME SERRAT | JUANJO PONS | RICARD PLA | JORDI ESCANDELL | LAIA MORENO
SEBASTIÀ TORRENS | XAVIER CARRERAS | LLUÍS BERTRAN | FRANCIS ABBOT
ISOLDA DELGADO | JOAN PETRUS | CARMEN VILA | ORIOL ALEU | MANOLO SOSA**

TRIANGLE ▼ POSTALS

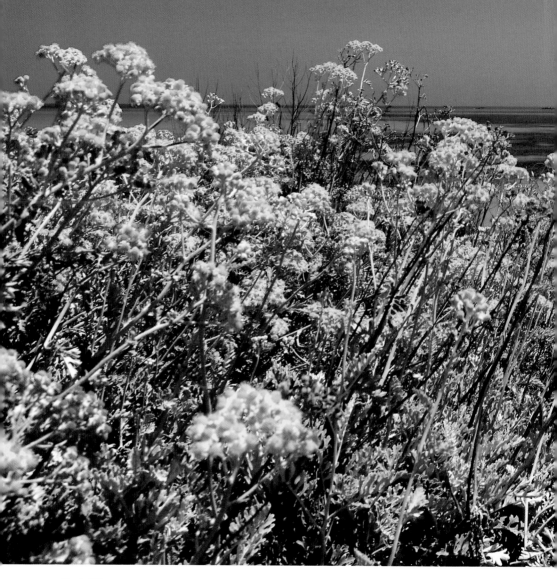

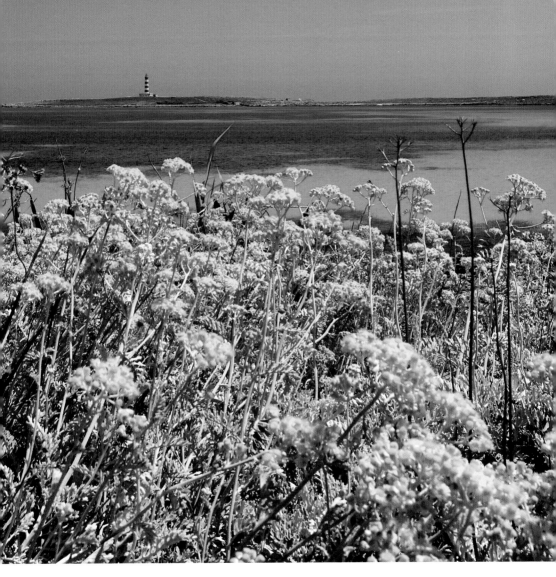

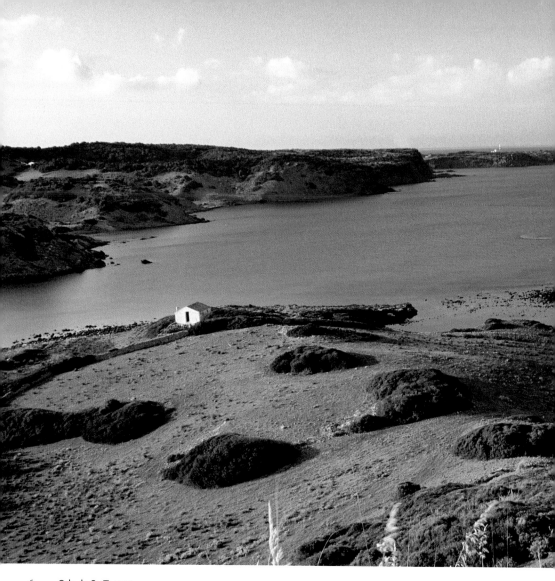

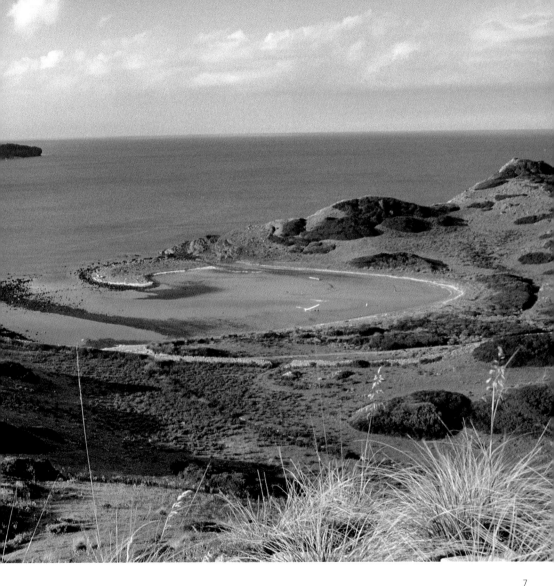

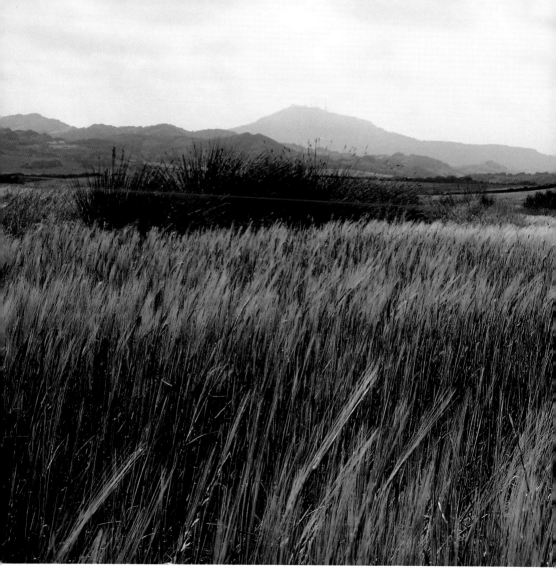

8 · Field and hills in the central part of the island

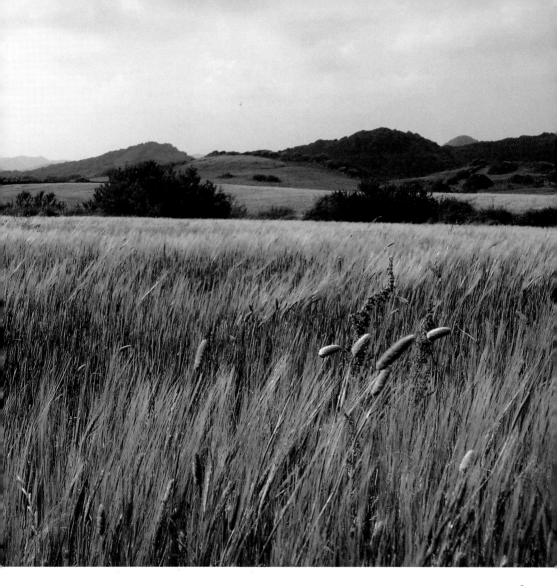

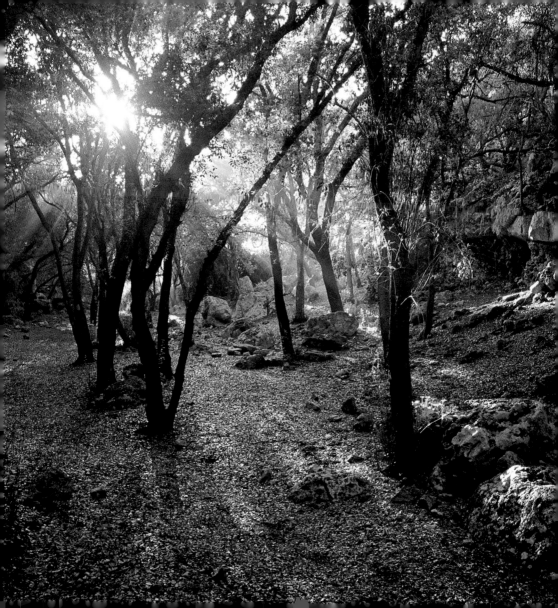

When life was still just an anecdote and the future was exactly that, a piece of land was formed in the middle of the seas. In the very centre of the western Mediterranean, the sea then knew an equidistant point from the peninsular coastlines of Hispania, from the Golfe du Lion and the large islands of Corsica and Sardinia; with more islands to the south, the other Balearic sisters, and further, the North African coast, Algiers. A point of metaphysical force, a hazardous fancy of the gods that rule life in the same way as the changeable winds capriciously swing a ship to and fro.

Unlike its sisters, Menorca is an eminently flat island and this is a characteristic that does not arouse either lust for control or great ambitions for power. Santa Àgueda (with the remains of an Arab fortress), S'Enclusa (with the remains of an American air base) and the Toro (with an old convent of Augustine friars –today a commercial and spiritual centre– and the addition of the radio antennas), are the only outstanding elevations. It is curious that in the early days of *pla català* (1), around the 12th century, some translators preferred, instead of the word "island", the roundabout expression "a mountain in the sea". The fact is the navigator is guided by signs, and mountains and hills are the most visible. In Menorca, the Toro is the *turó* (hill) par excellence, a "mountain" of 358 metres. This is recorded in the

◄

Rafalet ravine

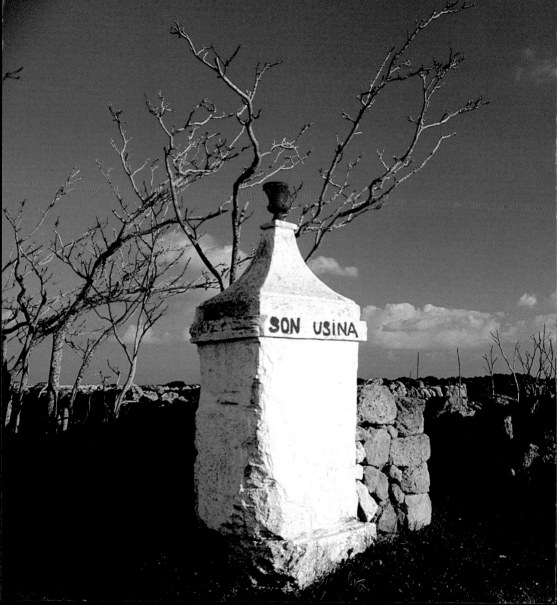

"The navigator, whose name was Bernat Ponç, from the city of Barcelona, ordered a sailor to climb the mast, since he must have been able to see land. And the sailor climbed up and immediately saw the Toro of Menorca."

Chronicle of Bernat Desclot when, in chapter 104, we are told of the voyage of Pere the Great from Sicily, returning to Valencia, in 1283. A heavy storm took the royal ship off course from his route and, on recovering the fair weather, after three days in which they had eaten nothing, *"lo nauxer, qui havia nom Bernat Ponç, de la ciutat de Barcelona, dix a un mariner muntàs en l'arbre, que terra devien veer. E lo mariner muntà sus, e mantinent, viu lo Toro de Menorca* (2).

In order to understand an island you have to reach it by sea. Sa'id ibn Hakam arrived at the port of Medina Minûrka one day as tax collector of the Almohad Vali (Moorish governor) of Mallorca, but once the Treaty of Capdepera had been signed –by the Menorcan royal tax collector Abu Abdallah and King Jaume I–, it did not take long before he became the "rais", which meant the main religious and political authority of the island. He was a notable poet who left these verses: "Menorca is excellent and its people honourable; God brought the rain to us all! (...) Menorka has the M of magnificence, the N of nobility, the R of realism and the K (or C) of collective cohesion. I love it with a melancholy love, the love of whoever misses the union with her. If I was the doorman of Paradise, I would say: People of Menorca, enter all, settle here in the most exalted place of all."

What more can we say. There are cursed islands where there are hellish apparitions, spells cast, storms and dangers, and there are blessed islands, symbols of earthly paradise, through which flow the rivers of life and death and that of eternal youth. These latter isles are "the land of the living", the goal of the medieval maritime pilgrimages. This is the meaning of the exaggerated –but nevertheless sincere– praise of Sa'id ibn Hakam.

From a symbolic point of view, an island evokes notions of solitude, reclusion (perhaps even death: at the end of the day the fate of an island is to sink!), but also refers to those of thrilling or initiation

Entrance to a country estate

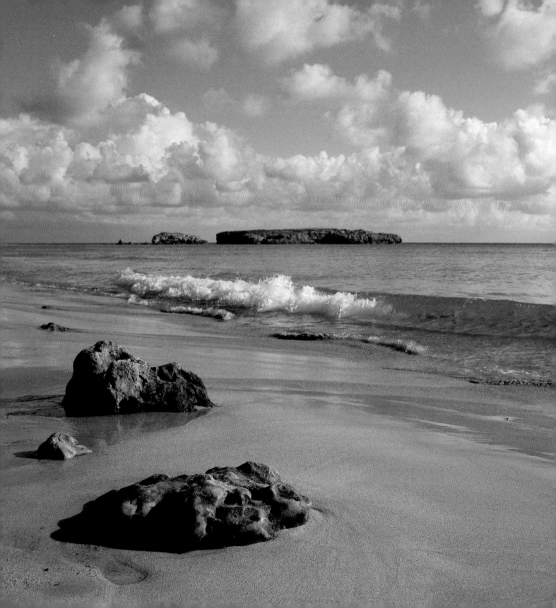

adventures. In literature, islands are often turned into a kind of paradise full of charms and treasures and, from the seaman's point of view, represent the security of dry land as against the beating of the waves, the refuge from the threat of the sea. From the sea emerges the unknown and all fears; but the sea is also the way to freedom, trade, knowledge, opening up. They say that the Menorcans are reluctant to open the doors of their homes, but once they have overcome their misgivings, they are absolutely marvellous at sharing, are cordial, generous and welcoming. The sea, then, would have restrained the islanders. In this sense, this people would be a synthesis of awareness and willpower. I really believe that nothing expresses better the sense of belonging: aware of the natural limits, so precise, and of the very limitations of their isolation, and the firm willpower of overcoming, of being deeply-rooted in the island's reality, of continuing to make progress on the island. The observer perceives a rich and diverse microcosm in its density, made to a human scale. Like a kind of atavistic wisdom, here life pushes harder, with the weight of great dreams behind ...

In this small and tidy home, history has evolved like the folding and unfolding of flags. Over the centuries the Menorcan people have seen it in all colours. If we look at antiquity, the archaeological remains tell us of primitive peoples from the Bronze Age until the Islamic settlement, with evidence of those who dominated the Mare Nostrum. In modern times, the European powers (Spain, Great Britain and France) coveted, in particular, the strategic location of the port of Maó. Beyond the historical changes, however, the four red bars over the golden background of the Crown of Aragon, and the Catalan language, have been, since the major change of 1287, the main symbols that express the Menorcan identity. An identity open to the most fruitful ethnic mixing and multiculturalism, of course, but perfectly placed within a Catalan identity that is expressed in the simplest cultural forms (language and place names, customs, cuisine, beliefs and traditions, etc.) and which enabled, not that long ago, the world to be ethnocentrically shared out

Islet of Codrell opposite
the Sant Adeodat beach

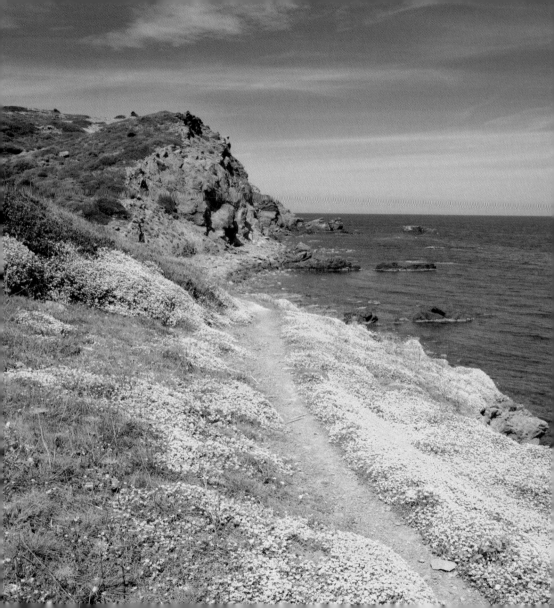

between the people of Menorca, Mallorca, Ibiza, Valencia and Catalonia, against "outsiders" and, in more recent times, "foreigners". Past and present coincide, therefore, in an expression, "We, the Menorcan people", in a complex society with contradictory interests, with a past made up, principally, of precariousness, work, migrations (it is difficult living on such a small and limited island!) and a present with decisive challenges.

Frankly, it is not a good idea to take as read the most clichéd information about Menorca. The best thing to do here is to look at the island with a fixed glare, just as we would before a mirror, delving into what we see until discovering –people in the world– its precise size. This is an island, a sea horizon; perhaps, though I am not certain, a way of being, projected into the future.

The book you are holding invites you to discover this Minor Balearic Isle. As you get to know it, you will begin to love it. And if you are visiting or you decide to do so then enjoy your stay, be lucky on your trip and may life treat all of us with dignity.

Ibn Yamin de Alzira, who was the secretary of Sa'id ibn Hakam, said of her that, "Menorca is the apple of the sea's eyes". He may have exaggerated –good poets do–, but how right he was!

Coastal path
on the northern coast

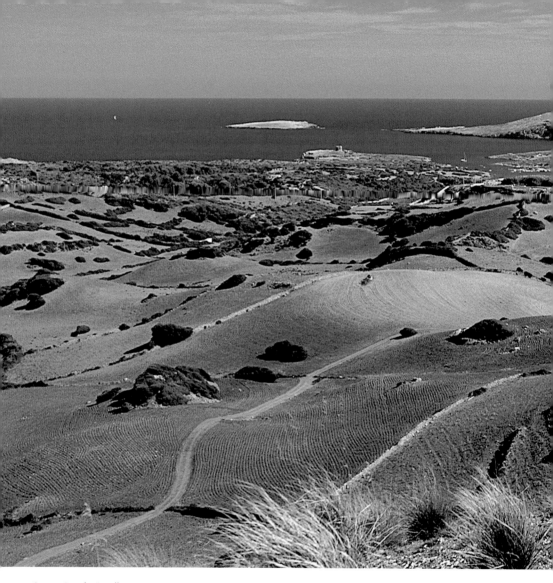

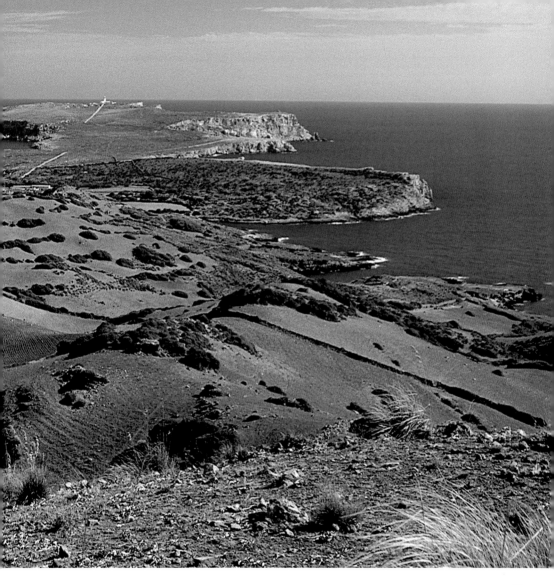

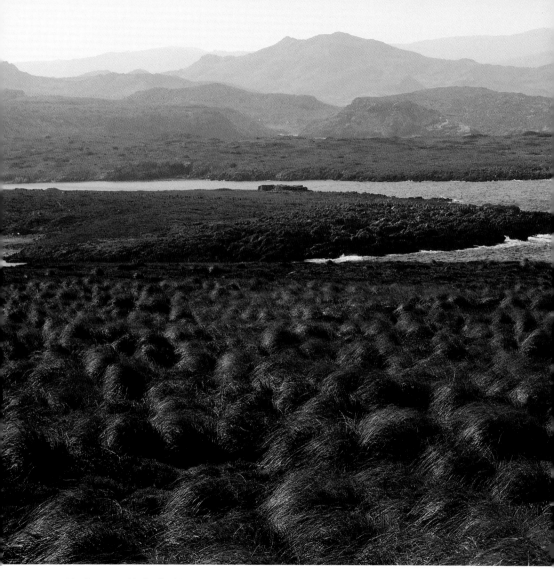

· North coast, with the Sanitja tower

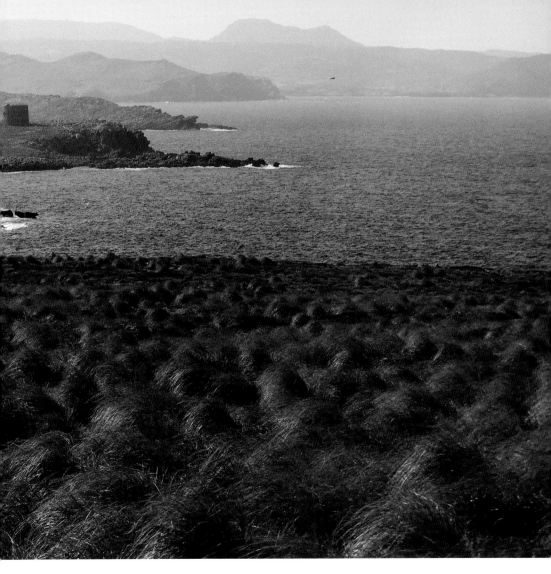

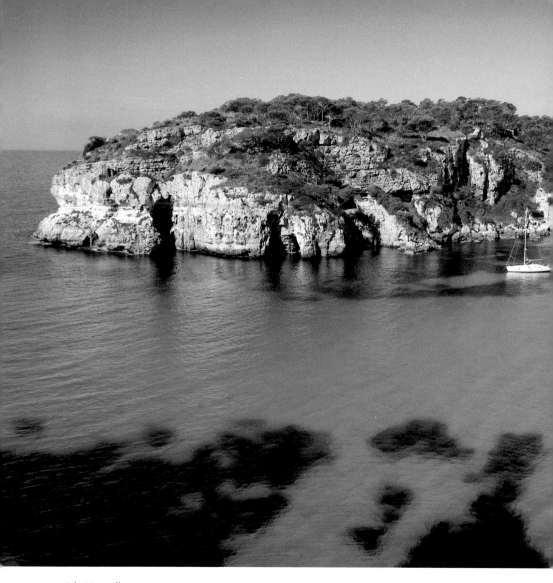

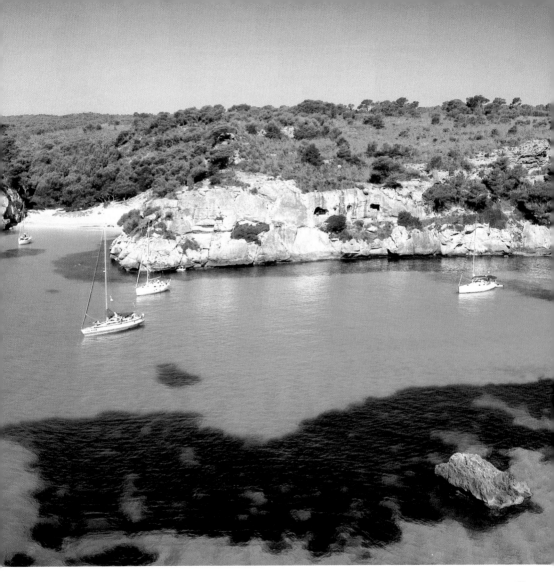

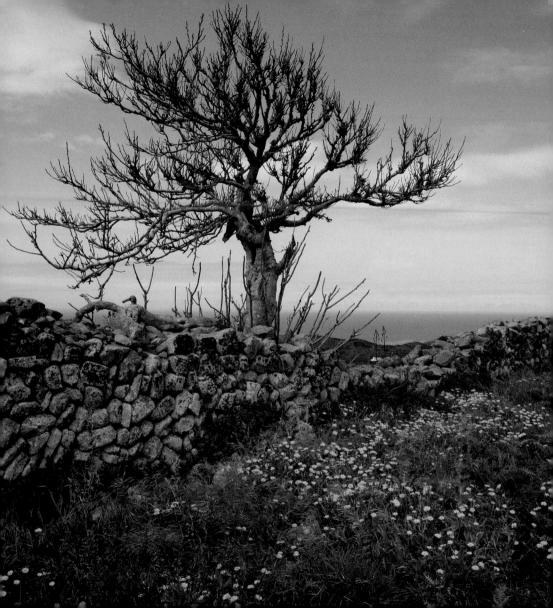

t is said that a fatherland is a sphere for coexistence, the place where the links that each person makes with others are established, a country of reduced limits in which previous generations have left their mark and where people want to live, and live well, at the same time looking towards the future.

The "Minor Balearic" island is little more than 668 square kilometres. Forty-seven kilometres separate Es Castell from Ciutadella, which are, from east to west respectively, the most distant towns, whereas between the north and the south the maximum distance is less than twenty kilometres. Its shape is an elongated and slightly arched island from the southeast to the west. The middle of the island is the crossroads of parallel 40N with meridian 4E and these coordinates show that Menorca is in the very centre of the western Mediterranean, almost equidistant between the Iberian Peninsula and Sardinia, and from Languedoc and Algeria, a fact that gives it a strategic position for navigation, which has shaped its history significantly.

One can establish the Menorcan personality, even from a primordial position, in its geological formation. It is the only island of the archipelago where one can see outcrops of Palaeozoic materials and is very different on either side of an imaginary line which,

Fig tree at the
beginning of spring

starting from the fault that divides the port of Maó, it would coincide with its longitudinal axis (more or less where the main road passes). This division leaves a southern area (*migjorn*) uniformly Miocene –the calcarenite carbonates or *marès* stone, spongy and aquiferous and with a great many fossils of marine fauna– and another northern area (*tramuntana*) made up of Palaeozoic and Mesozoic materials, with fillings from the Quaternary, the combination of which provides a relief of small hills and shallow valleys.

Only with the perspective at the scale of a small country can one appreciate that the terms may seem exaggerated for some: the "mountains" of Menorca have their Everest in the Toro, the biggest "river" is the torrent that squeezed out the Algendar ravine (due perhaps to the fact that it is one of the few permanent water courses), the "lakes" are mere pools or ponds, which are dry in summer, and the two lagoons are not really very big at all. On the same lines, in a land where it only snows once every twenty years, hailstones are now "snow", and it seems that the people from one end of the island to the other are still too lazy to cross it by road... even when this represents just over half an hour's journey. Josep Pla mentioned this when he said, "the smaller a country, the longer the distances. Everything points to what is particular. When you have acquired the taste for erudition (curiosity) and study, the island of Menorca provides you with an experimental field and unending reading."

The island's vegetation does not differ from typical Mediterranean landscapes: woods of pine, holm-oak wood, coastal areas sprinkled with scrubland, rocky fields difficult to cultivate, a few orchards, small estates and allotments, always protected in the ravines or protected from the wind. In this collection of samples, two elements have a clear symbolic value: the *ullastre* and the *socarrell*. The olive (*Olea europaea*), –"...*és l'ullastre centenari/ com un monjo solitari/ resant vora el caminal...*" (Àngel Ruiz i Pablo) (1)– curved, almost being dragged towards the south in order to avoid the assaults of the Tramontana wind, dry and cold, which often swoops

►
Lighthouse of the
Illa de l'Aire

1
"...is the centennial
wild olive tree, praying
beside the way like a
solitary monk".

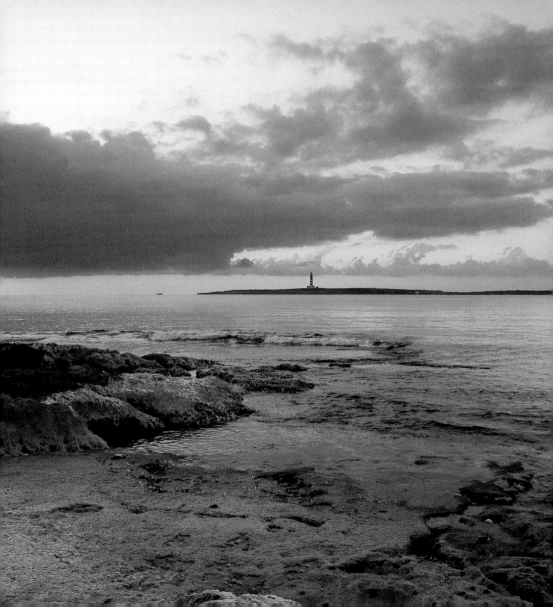

over the island, via the Golfe du Lion; in fact, its inclination is not solely due to the strength of the wind: the "reverence" is caused by the salinity of the open sea, which is increased when it hits the rocky northern coast. Salt, which burns stems and leaves, the most tender and sensitive parts of the north-facing tree, makes it only possible to grow towards the south. More or less, as the same poet said with such epic force:

> *"La vésseu quan l'envesten furioses les onades*
> *i brama damunt ella lo nord o bé el mestral!*
> *Del blanc polsim de l'ona se n'alcen nuvolades*
> *qui com espessa boira cobreixen el penyal".*
> (Àngel Ruiz i Pablo: *Menorca*) (2)

...And the *socarrell*, *Launea cervicornis*, a shrub native to the island, thorny, hemispherical, aerodynamic and resistant to nearly all adversities, which is found on the coastal strip most prone to the strong wind and the sprinklings of salt. Apart from its simple beauty, the *socarrell* coexists alongside smaller plants of notable interest, which it protects, and its root system retains the soil and avoids erosion. In the past these plants were used as a filter for the rainwater in the deposits of the houses and, due to their rounded and spiky structure, got the name of *coixinets de monja* (nuns' cushions), referring to specific forms of penitence. For Menorcan ecologists, who publish the "Socarrell" magazine, this plant, "symbolises perfectly the tenacity and resistance to the attacks from the weather. Moreover, its unique and unrepeatable identification with the environment that enables it to exist means that any external usurpation of the right to exist and to express itself in the way it wants is quite impossible."

If we were now to take a brief look at the history of Menorca, we would see that the *socarrell* and *ullastre* are very apt symbols to represent the people who have put down their roots, resisted and grown in the territory for, approximately, 4,000 years.

Islet of the north coast

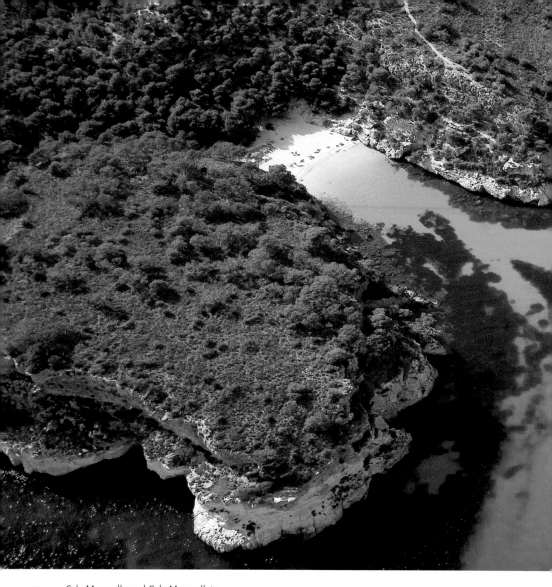

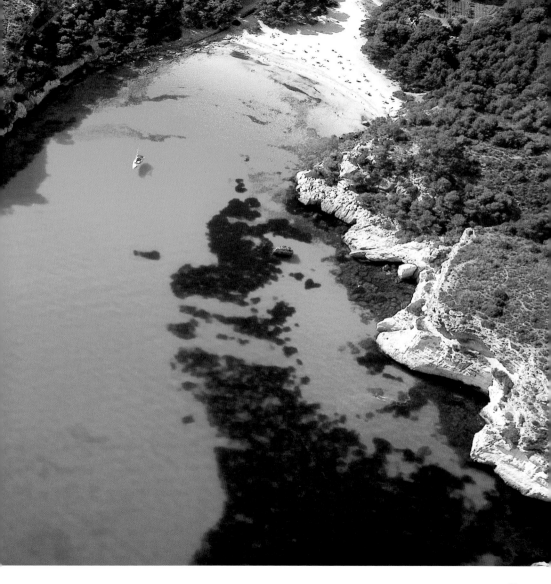

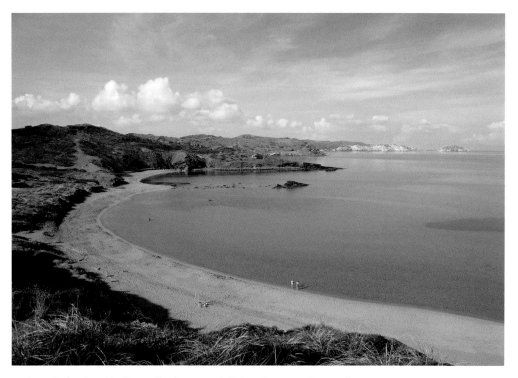

Look at the land and its lines will take you to infinity. The sea is the way, from the sea emerges the telluric strength that will make you rock, solid stone of being, craggy and solitary. And the Architect has designed you as the arch.

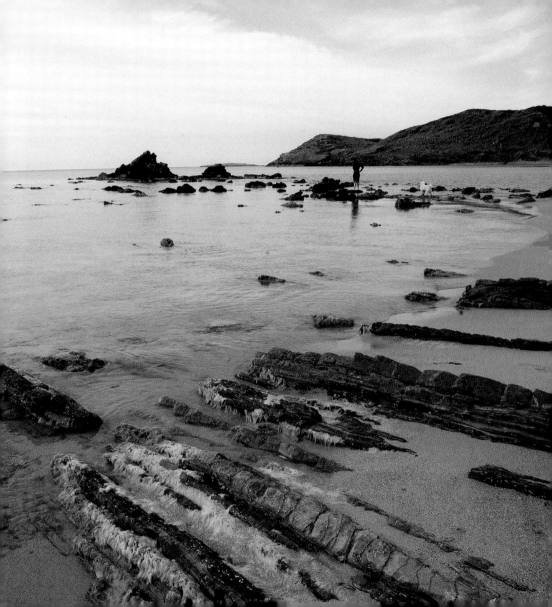

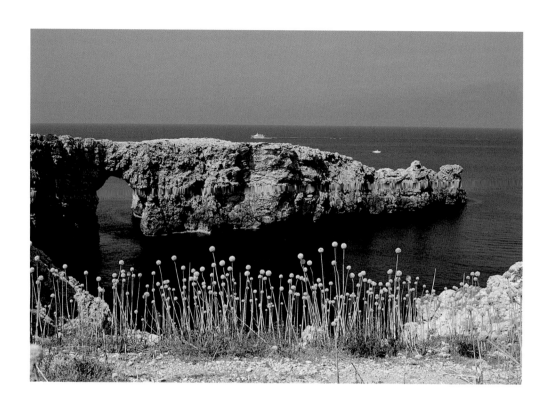

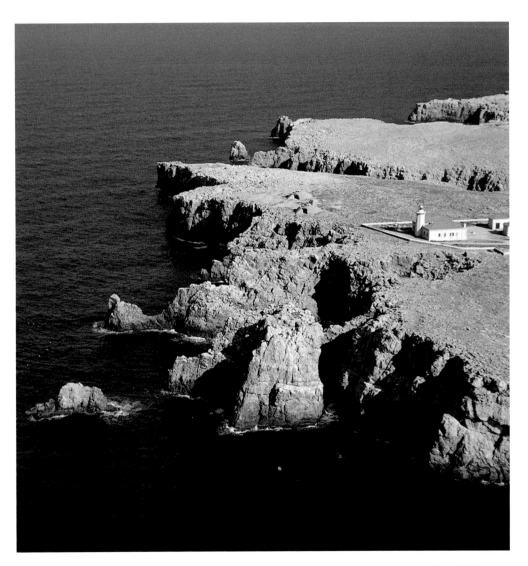

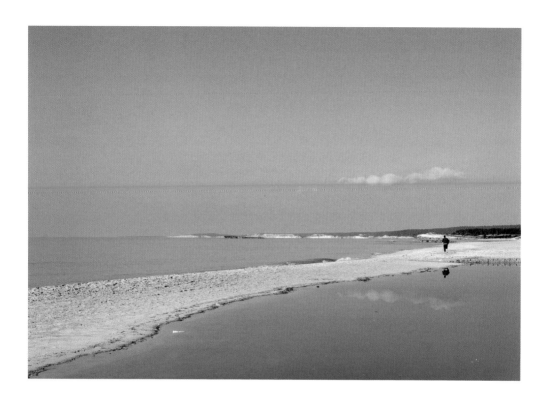

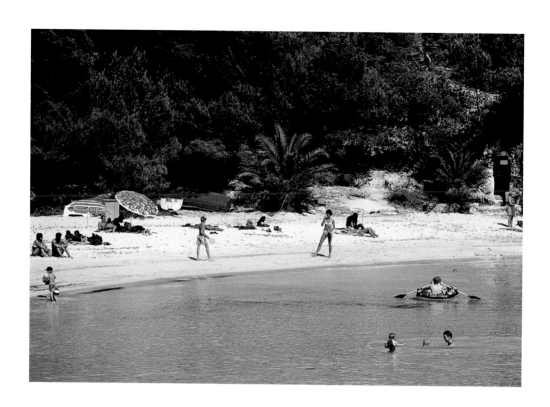

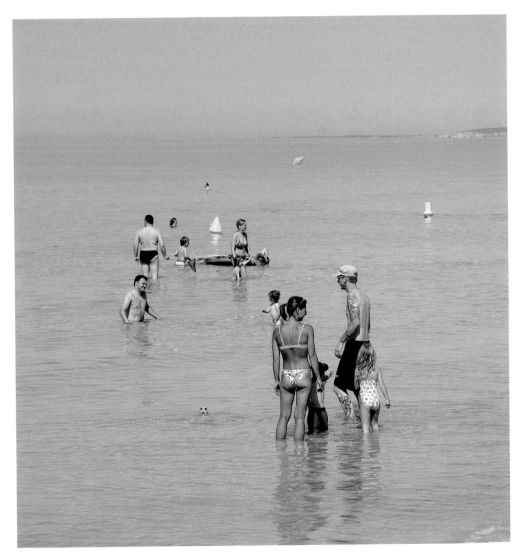

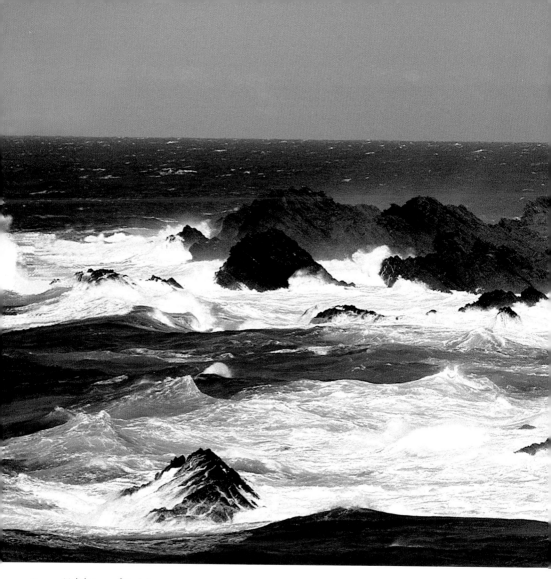

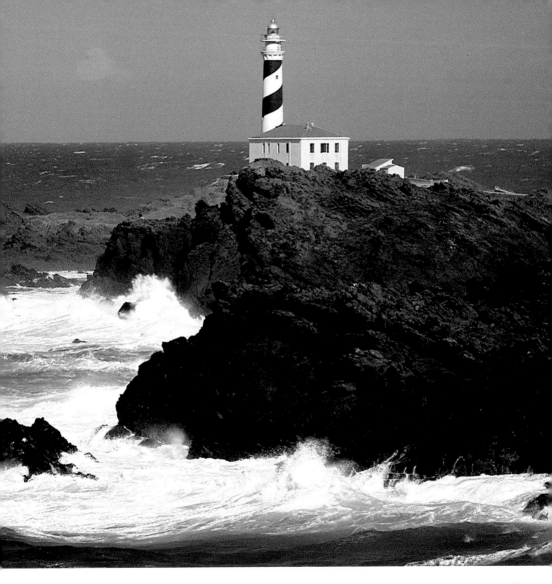

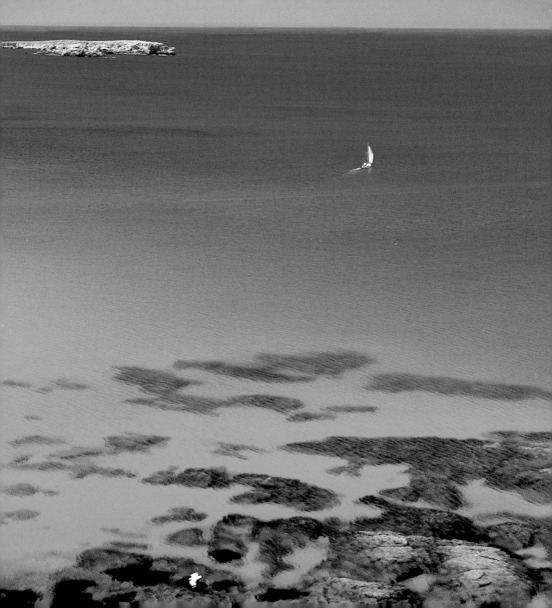

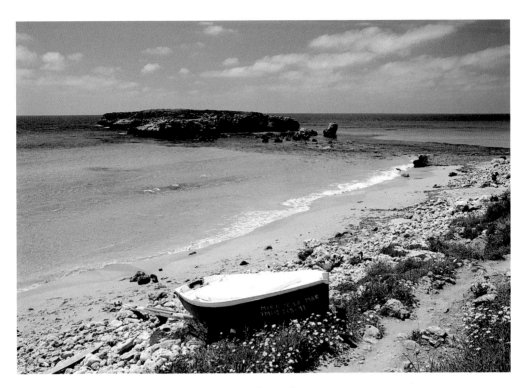

Avoid the rocks on your route towards the open sea during the years that life has given you, until Zeus tells you: enough. Then, the salt and the sun will erase your name and footprints from the sand.

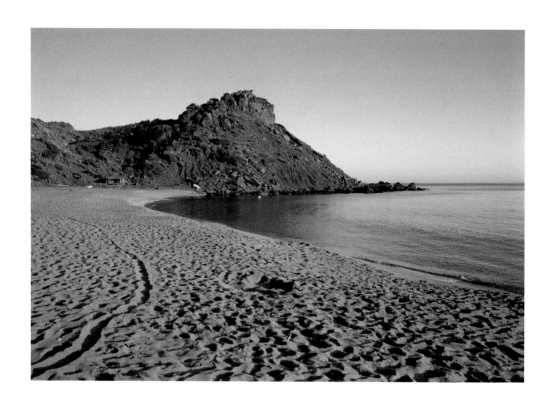

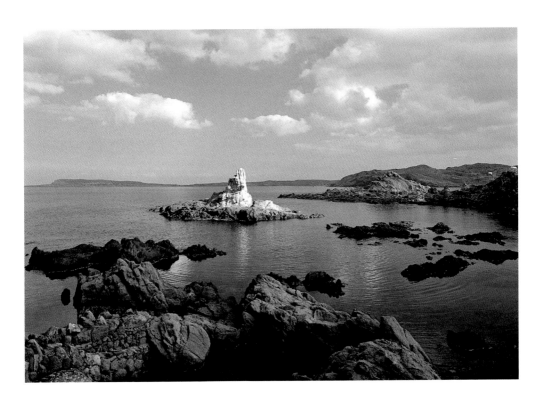

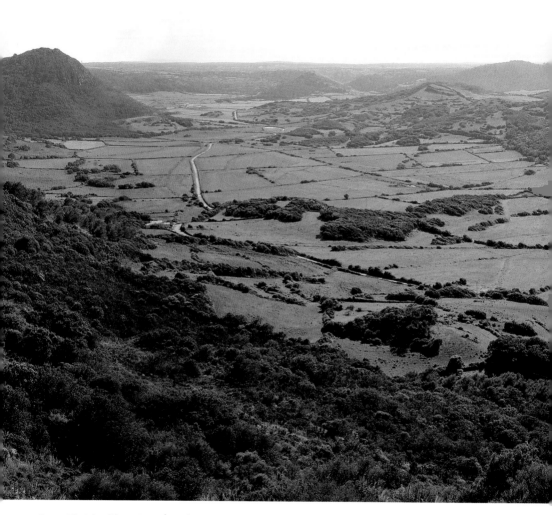

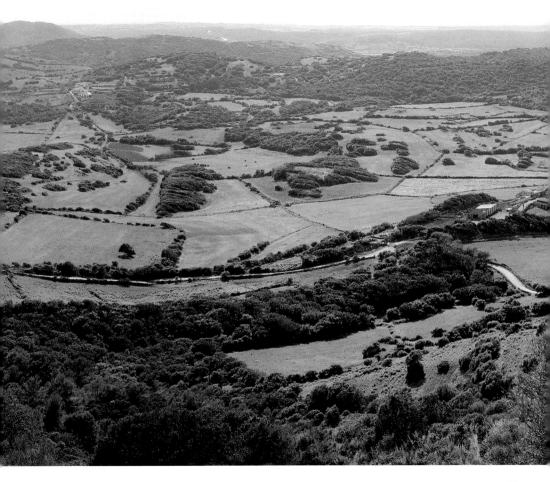

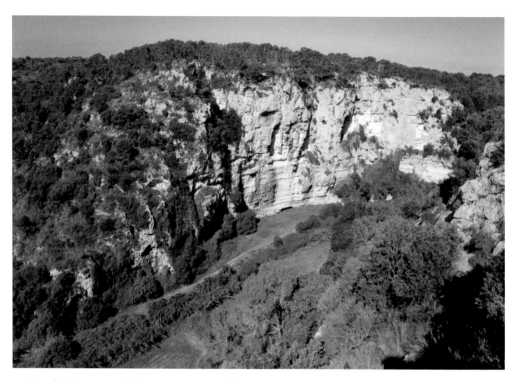

Ravine of white crags and deep caves, inaccessible. In the cretaceous
south, the water, like a machete, has opened up the veins of the
island. Or perhaps it is the millenniums that have combed its luxuriant
greenness with tracks of water. Depositories of fertility and of the most
prodigious springs, the ravines offered, and still do, a cultured option to
agrarian tasks –agriculture–; and at the same time, excellent fruit.

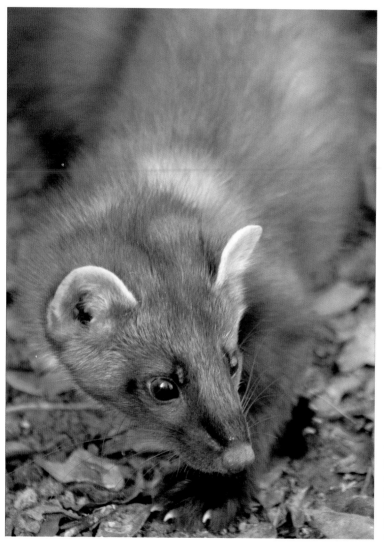

The vigilant eye −but not avoiding the glance−, alert to the mortal danger of predators; you smell the risk of living hidden in a natural environment which man has reduced to the limits of survival. And yet you survive...

◄

Marten (*Martes martes*), a rare mammal but still present on the island

►

Mediterranean tree frog (*Hyla meridionalis*)

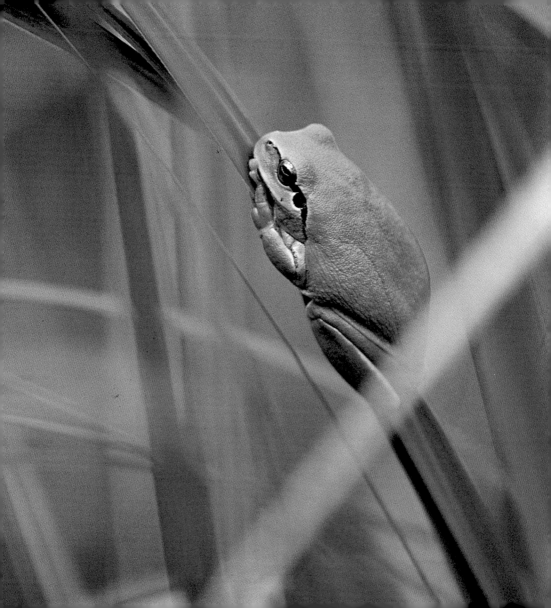

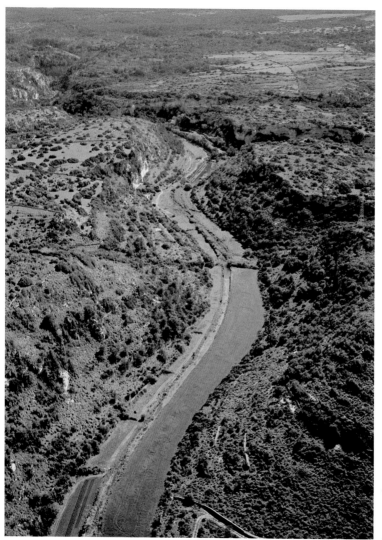

*The ravine has marked
the way for you, the path.
It is not you who decides.
The path takes you.*

◄

Trebalúger ravine

►

Pas d'en Ribell, in the
Algendar ravine

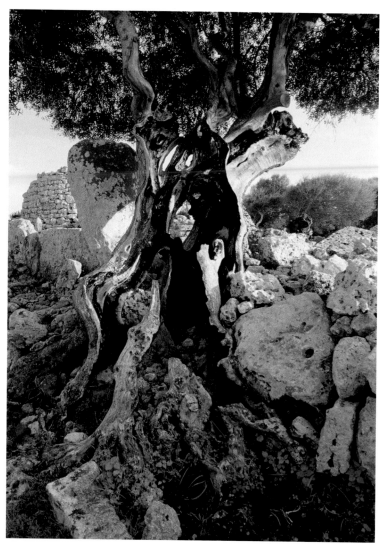

*Rock carved by life.
Life attached to rock.
Stay and go beyond.*

◄

Ullastre is an
archaeological site

►

Taula de Torralba
d'en Salord

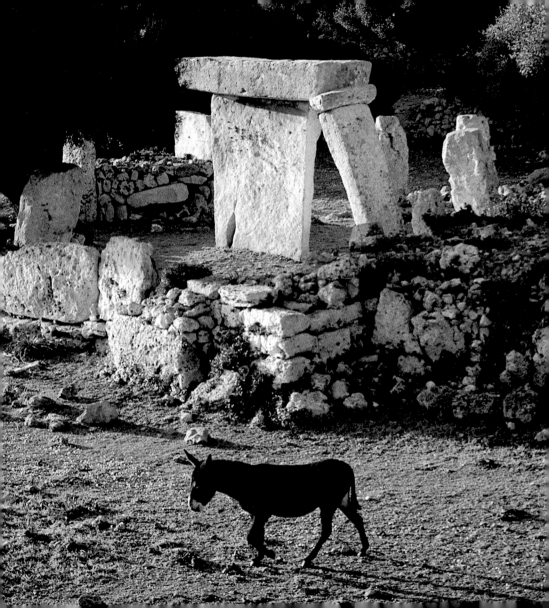

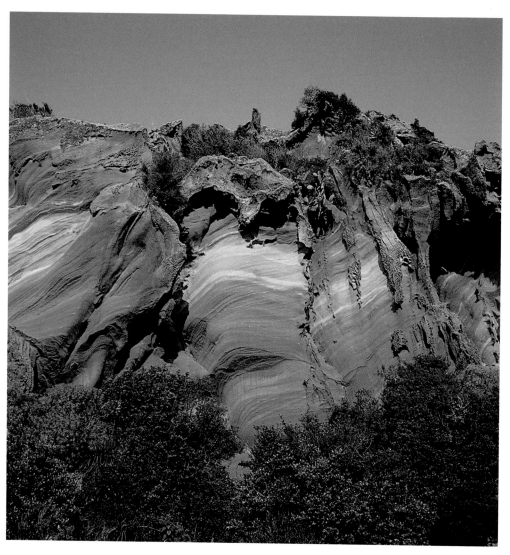

56 · You can see curious rock formations on different parts of the island

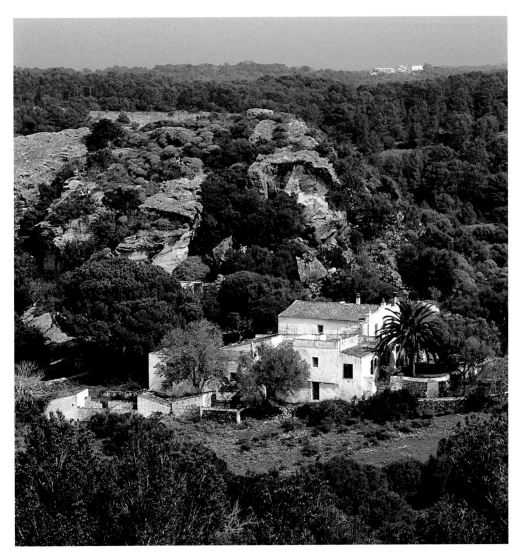

Egipte, rural property in the Alaior district ·

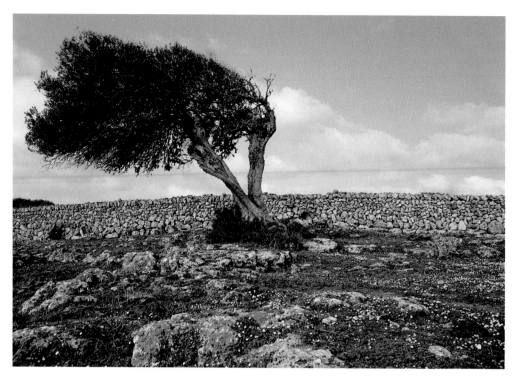

Two symbols. Like a solitary monk praying in a field, at the mercy of the wind, the hundred-year-old ullastre *(wild olive tree)*. At ground level, closer than the very earth, the socarrell *(thorny scrub)*, which, in its own time, miraculously flowers a demure yellow.

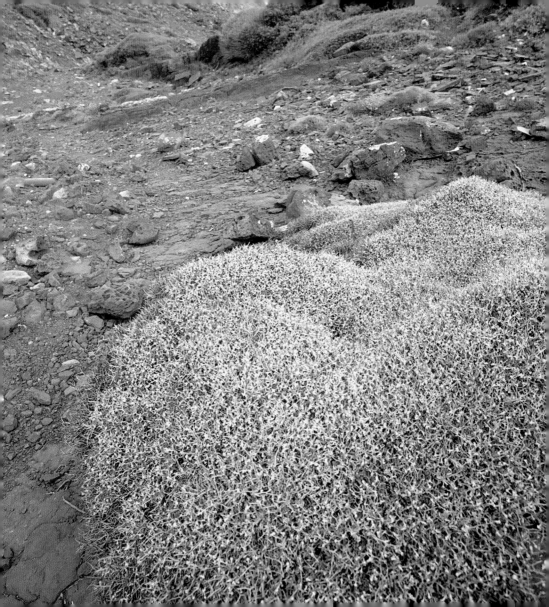

Menorca was declared "Biosphere Reserve" by UNESCO in 1993. Some of its natural spots reveal traits of sacredness and mystery to whoever observes them in reverent silence.

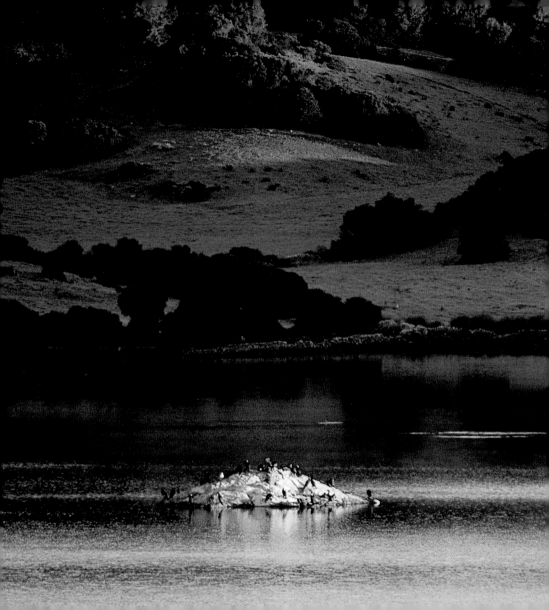

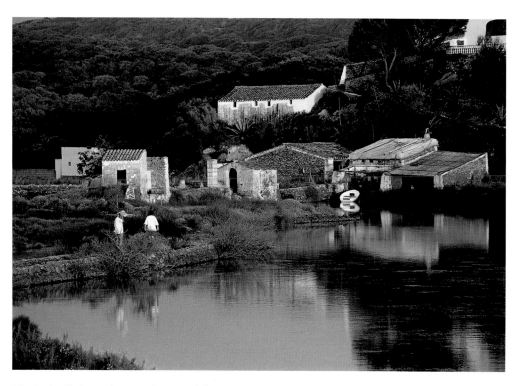

The Park still shows elements that reveal the ancient presence of mankind in this setting.

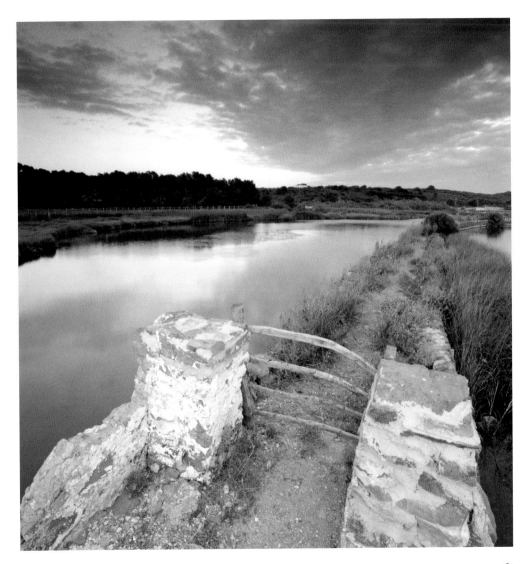

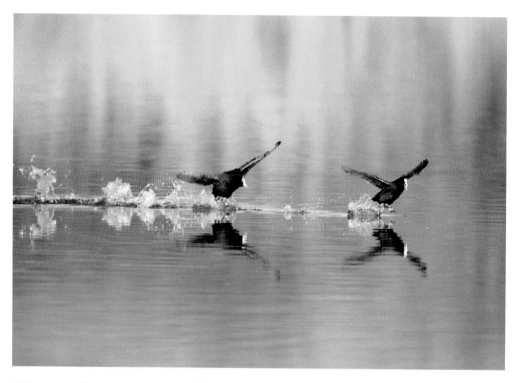

Enjoy time itself in the magical mirror of the days.
Finding two moments the same is nothing more than a mirage.

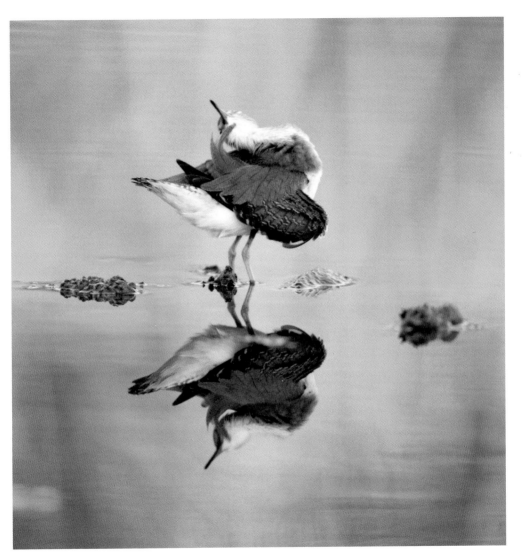

Sandpipers (*Actitis hypoleucos*) ·

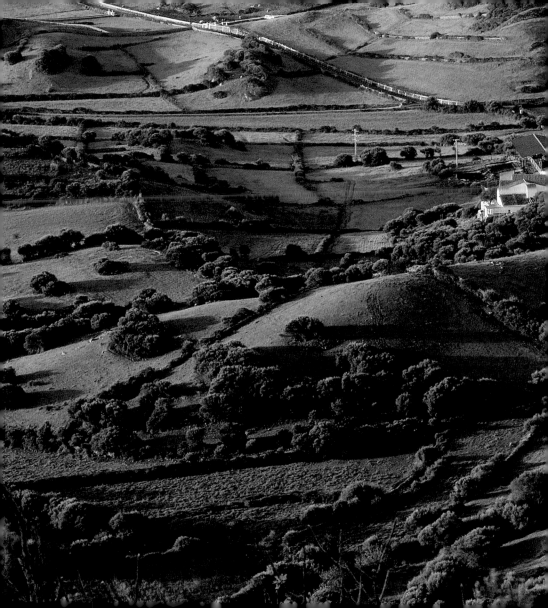

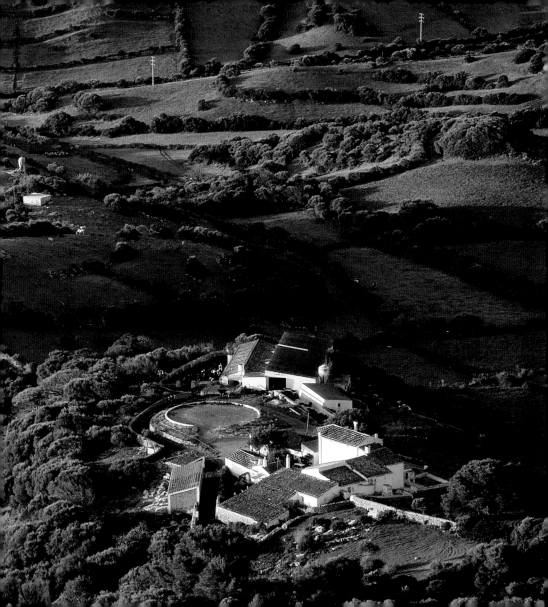

You find the track marks of the path that leads you home already made.
Others have taken the track before you; now they are yours. Higher up, the dry
stone wall is the milestone that the ullastre clings on to. It is not the tramontane
wind that twists it, but rather the treacherous salty drizzle that the roaring
swell raises. It does not incline its head, but looks towards the south because
of the inhospitable north and sees men fall, one generation after another.

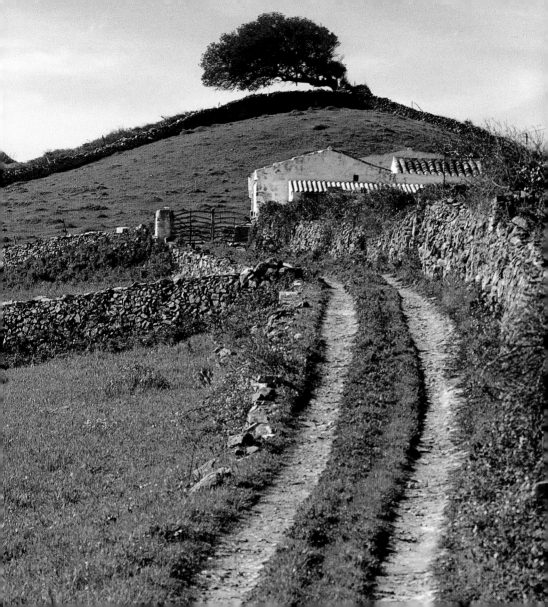

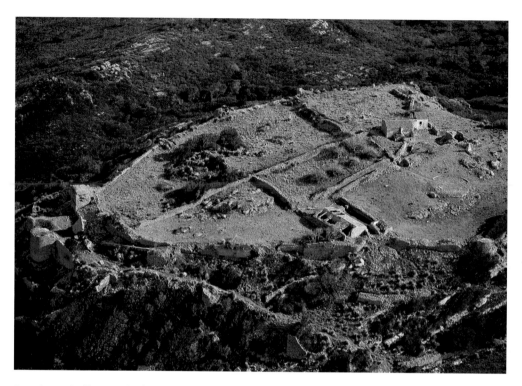

Sent Agayz, half moon, the last Menorcan Muslim leader and his people climbed up to their castle of light. In January 1287, Abu Umar Hakam ibn Hakam left to undergo a harder exile than the cobbled stones that he descended. The walls and towers abandoned, and the castle now in ruins, it once again became known as Santa Àgueda.

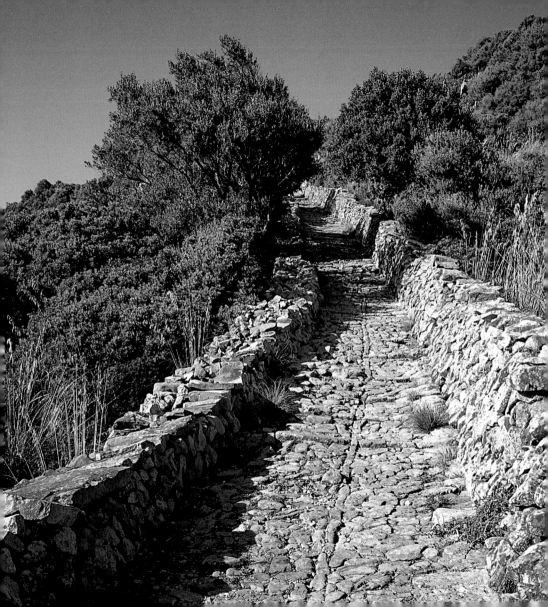

Paredadors *and* araders, *draughtsmen of the island. Lines that compose and outline the Menorcan countryside, enclosures that are not closed. The cattle are herded in, sheltered, but the way is free for people, for good people. The latch has no lock. "Qui va darrere, tanca sa barrera" (The last one through must close the gate).*

[*Paredadors*: dry stone wall workers, they build the low walls that separate the fields; *araders*: craftsmen in untreated wood, they make gates and tool handles from the ullastre]

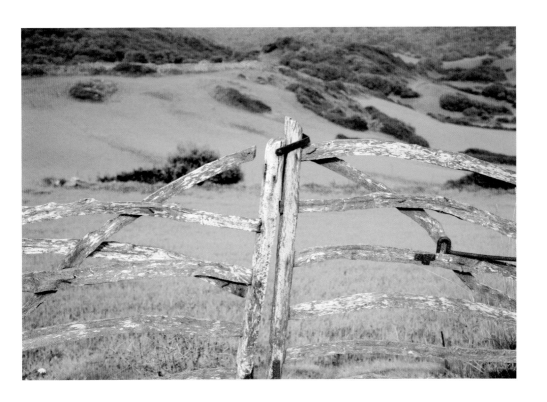

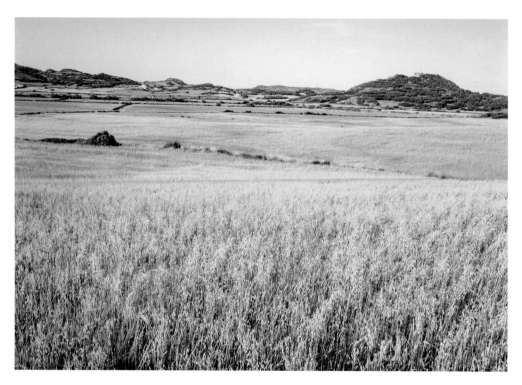

"No diràs blat, si no és al sac..., i ben lligat!" *which means that it is not good to talk about benefits before they have been made – (don't count your chickens before they are hatched). Summer solstice. Sweat and toil for gangs of arms, cutting and cutting ...* "Pel juny, sa falç al puny" *("In June, the scythe in the hand"). Once the bales of hay are formed, tightly wrapped in the string, they have been taken to the threshing floor. Once the wheat is threshed –the grain here, the straw there– the traditional share-out has been made. After all the effort and the agricultural year having reached its full cycle, the fields are parched from sunrise to sunset. The grain, passed through the hopper of the mill, will become flour with which we make bread.*

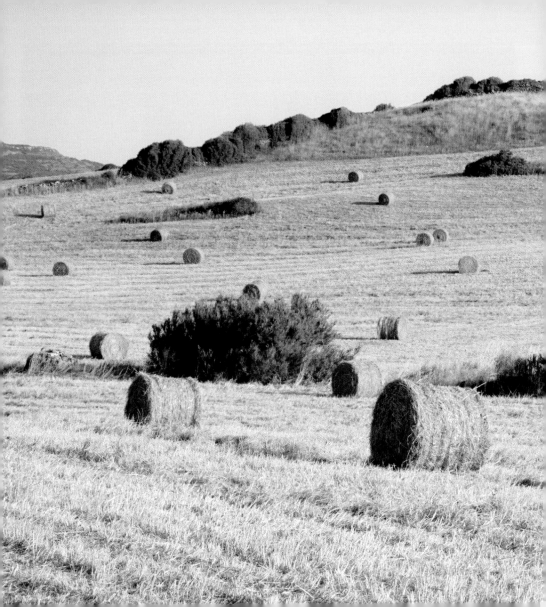

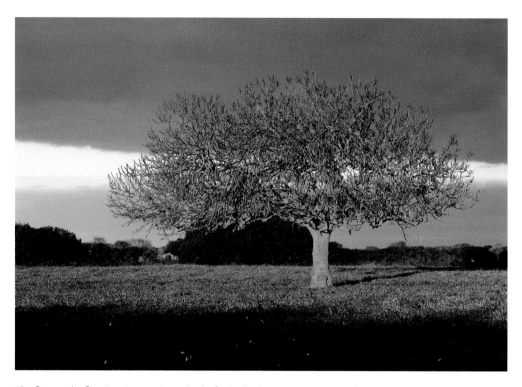

The fig tree, leafless in winter, misses the leafy shade that in summer provides freshness and produces the sweetest fruit. The fields were blessed with rain and the grass grew. Symphony of greens. The sun does not fulfil its mission, the sky calls for the cold: from white to grey passing through blue.

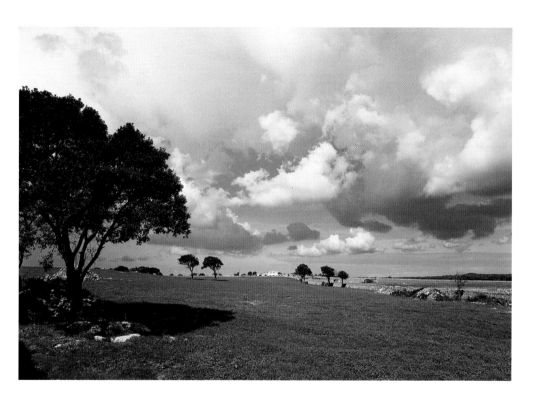

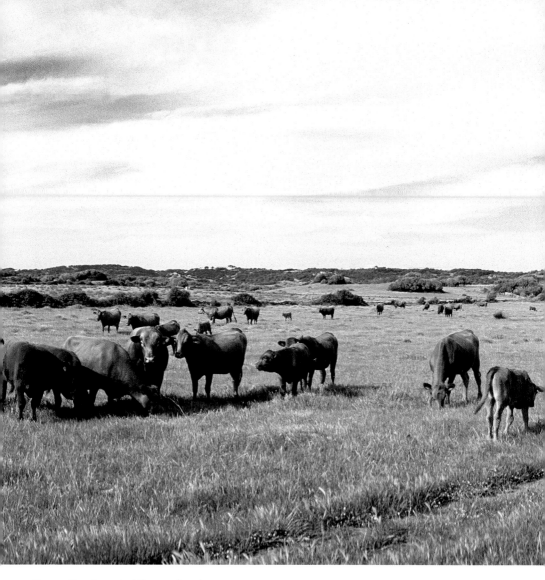

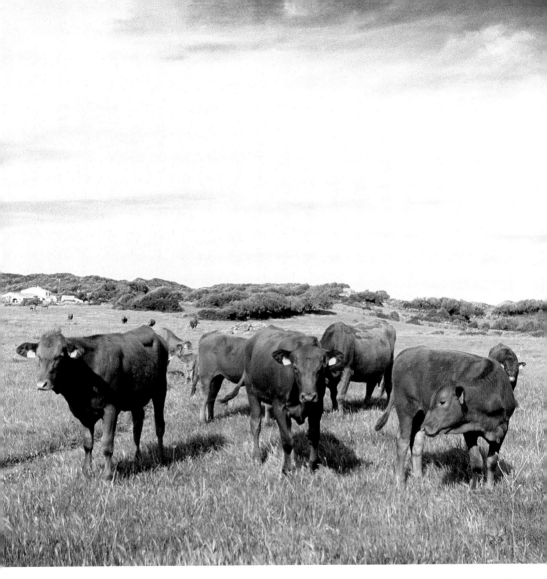

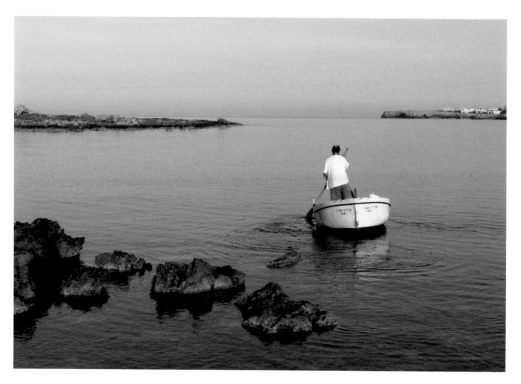

The seaside cottage is an unchanging referent for many Menorcans. Going for a "romandre" (to "stay over", in the sense of spending more than a day) in a cove, casting fishing lines at dusk, singing traditional songs accompanied by the guitar under the stars and going out to fish at daybreak. Cooking the fish "caldereta" or stew and ending with a good nap... Quality of life.

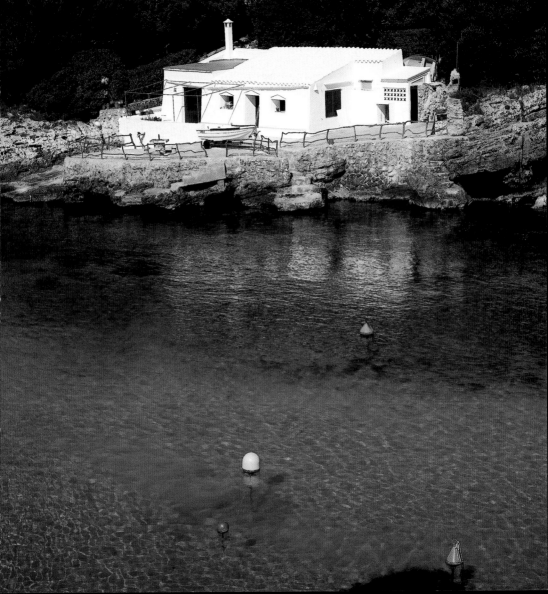

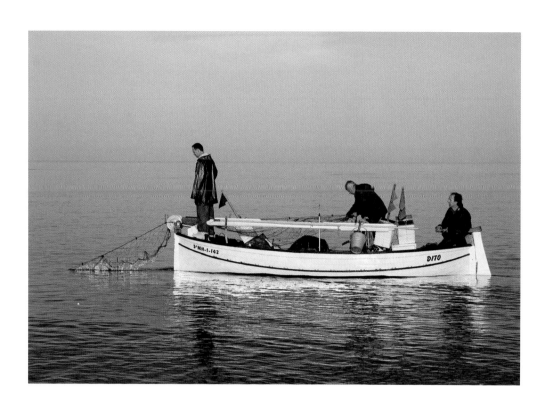

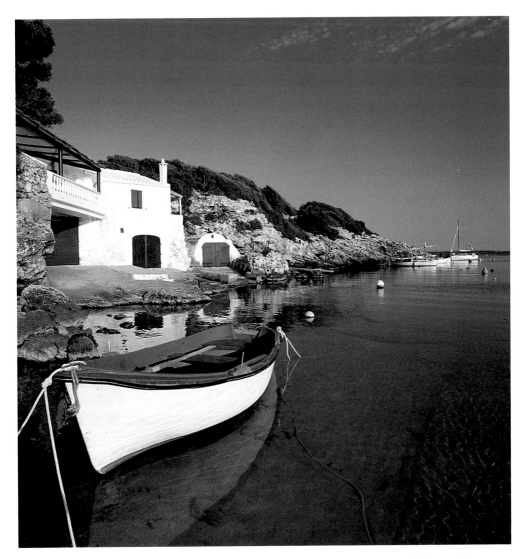

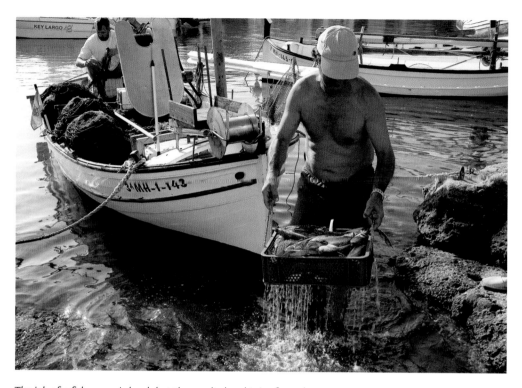

The job of a fisherman is hard, but the results he obtains from the sea are a festival for the senses: the aromas, colours and flavours of Menorcan cuisine.

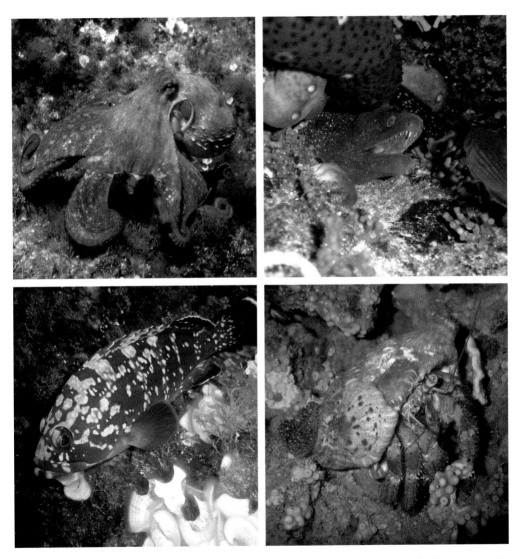

The marine fauna, as well as being varied, is also extremely photogenic · 87

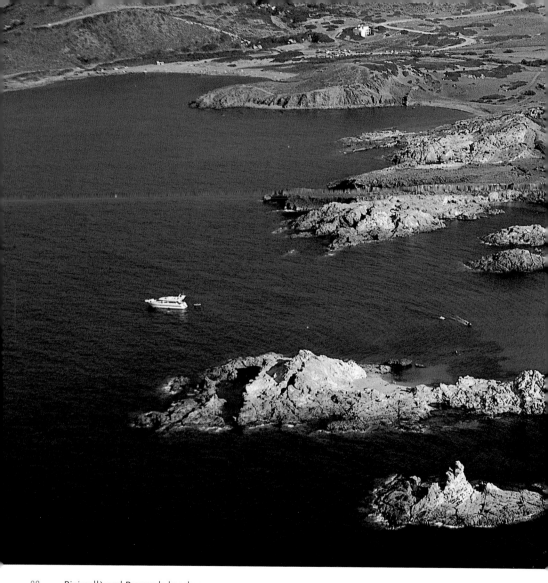

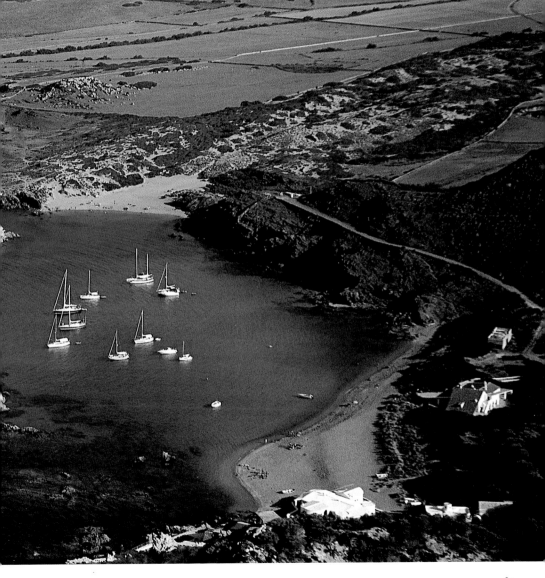

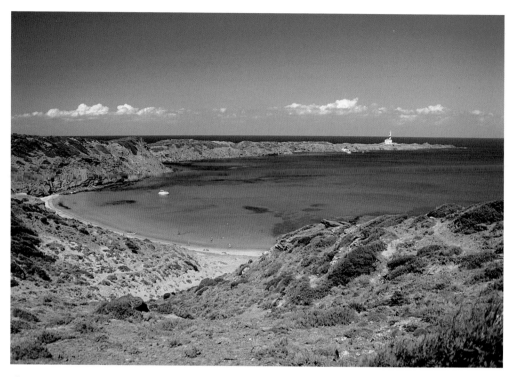

The Tramontana wind has created a profile of the north coast, irregular
and wild, in which the coves are open and living rock, with shingle that
is the result of the battle between the wind, which moves the swell,
and the haughty cliffs. The atmosphere is sharp and the diaphanous
light passes through the transparent crystals of air and water.

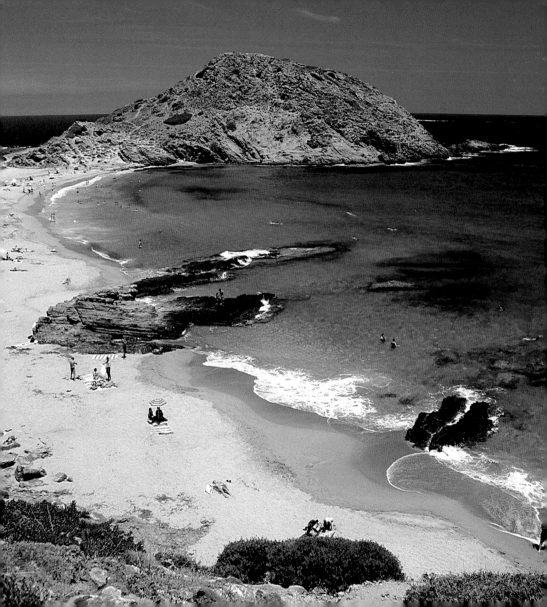

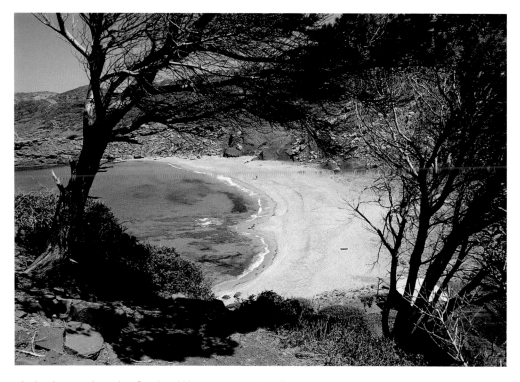

The hardness and weight of each pebble contrasts with its friendly, rounded shapes, which invite one to touch them. But the lure of the bright colours, with the shine that the water gives them, is a trap for bare feet.

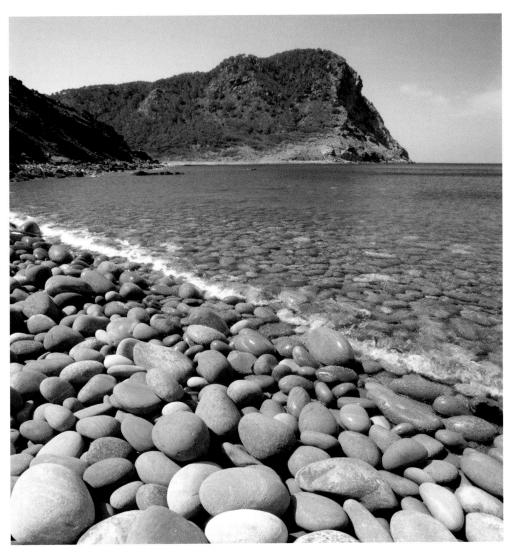

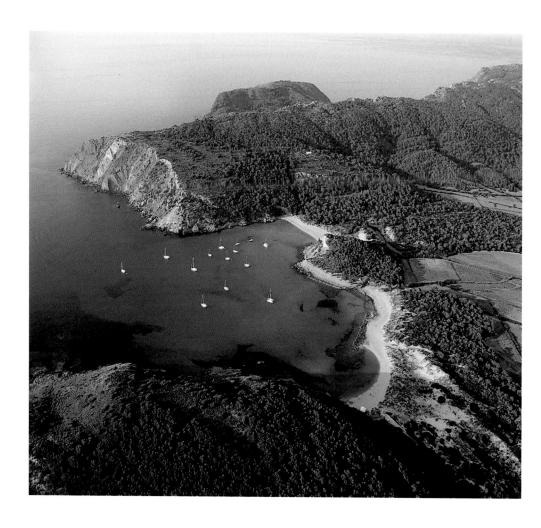

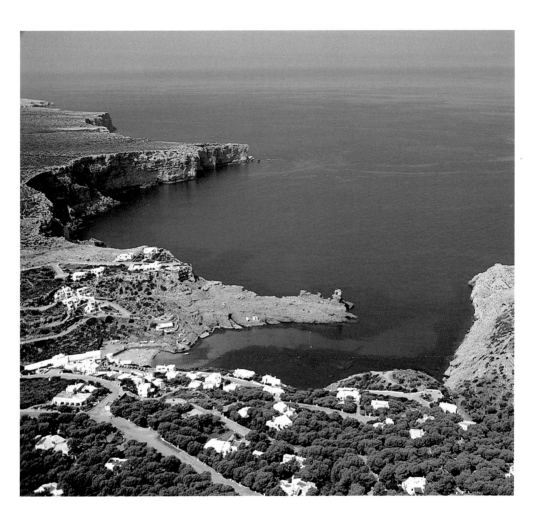

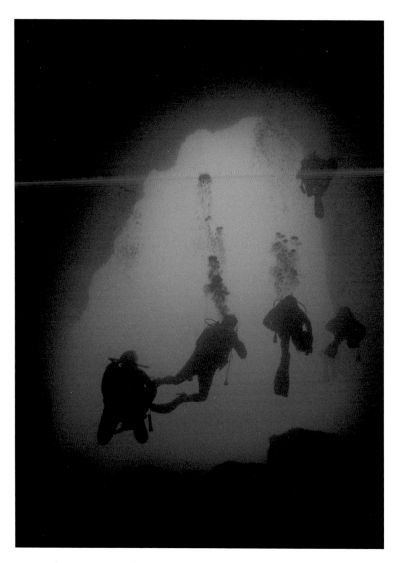

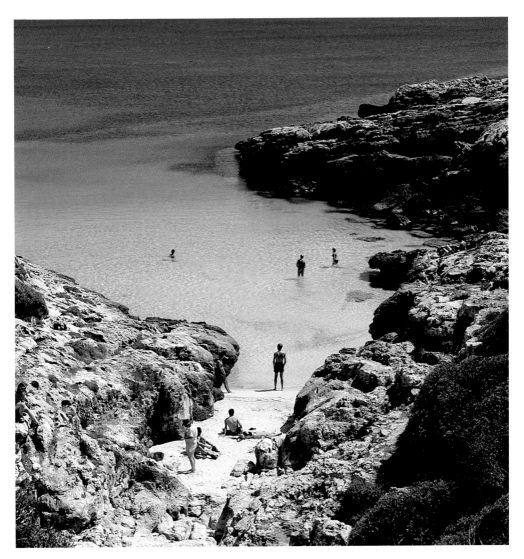

Es Calò Blanc, close to Binissafúller ·

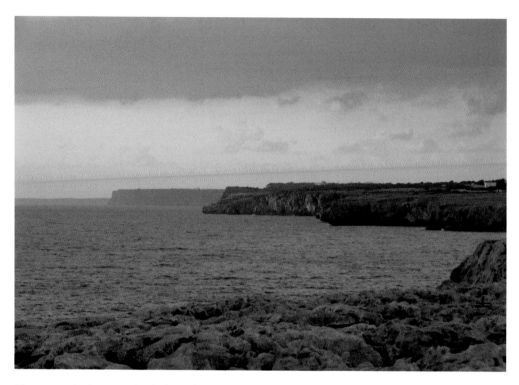

The sun sets in the west. The rhythm adjusts. You will not empty the sea, laddie, with your small bucket; you will not escape, seagull, by flying, from your winged fate by the domains of the air. Instants of childhood slip by which tomorrow will blossom as unforgettable memories. Calm at sea and in the hearts when dusk places a pinkish overtone over the warmed-up earth. Promises of a fresh breeze to shake off the recklessness of a hard summer's day.

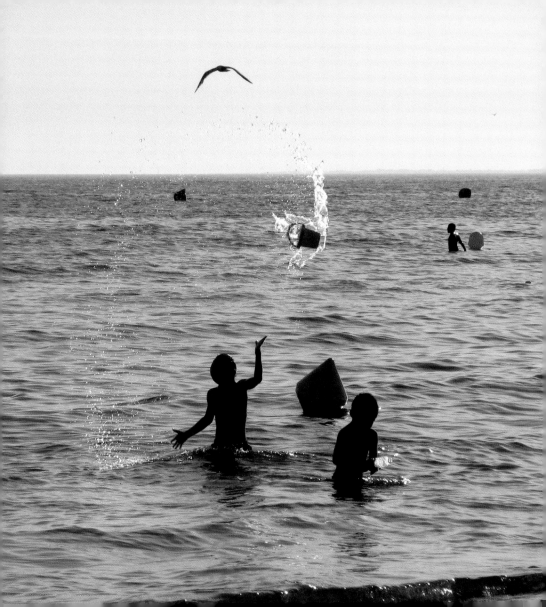

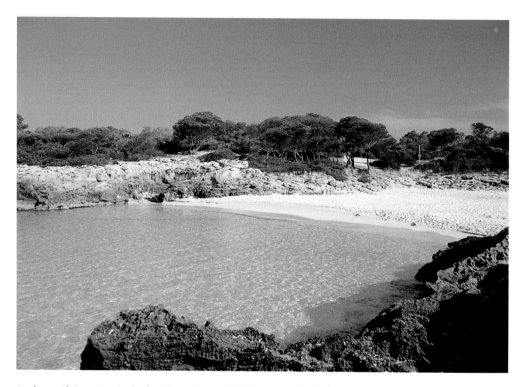

In the south in contrast, the beaches, clean and white, are an invitation to healthy and refreshing bathing, and a caress for the feet, which feel the warmth of the sand between the toes. The land surrenders to the sea and the coast is lower; the pine woods grow practically at the water's level and close to the shore.

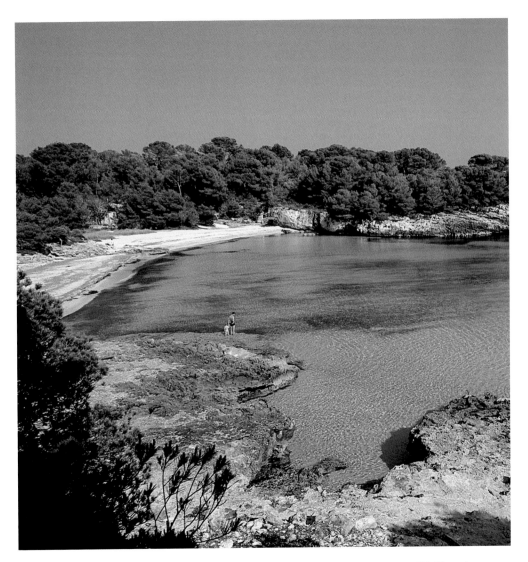

The cliffs of the south coast have many caves, such as those of En Xoroi, fitted out as a disco in Cala en Porter

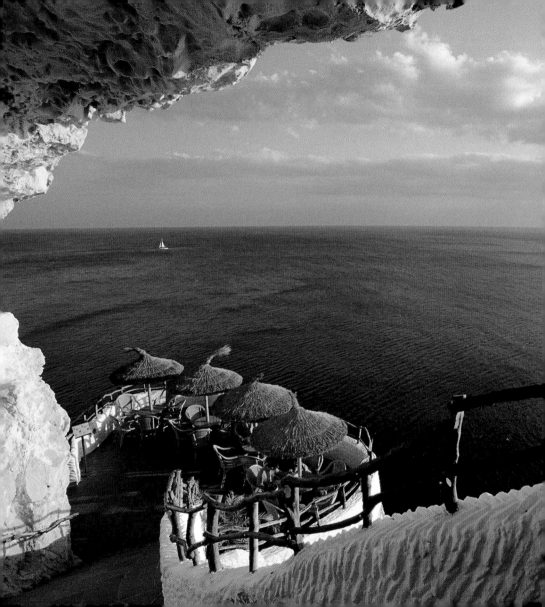

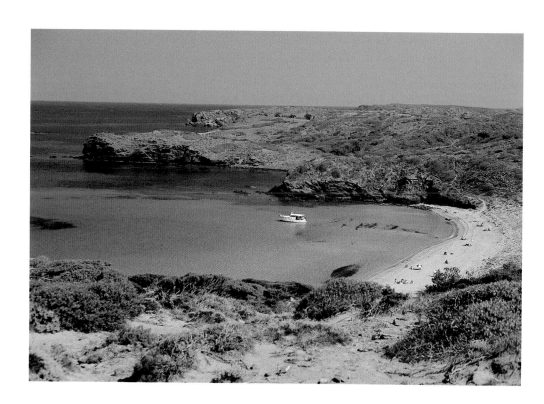

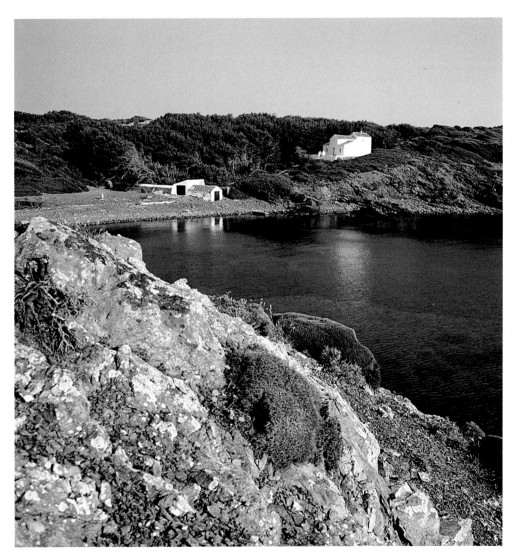

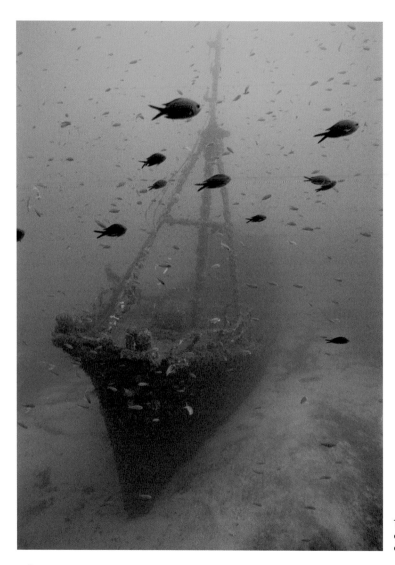

The many wrecks
ensure thrilling
explorations for divers

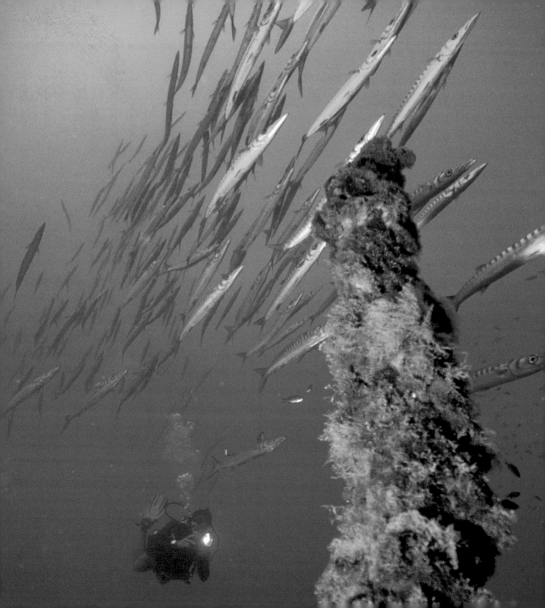

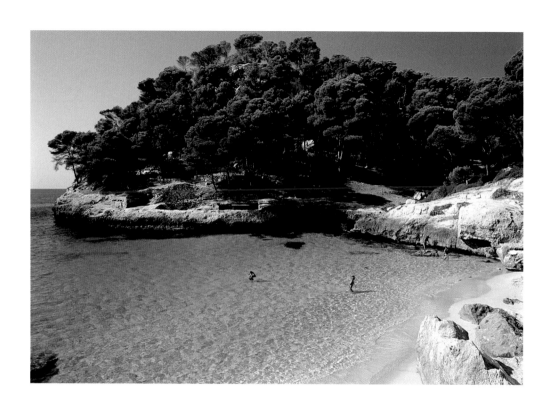

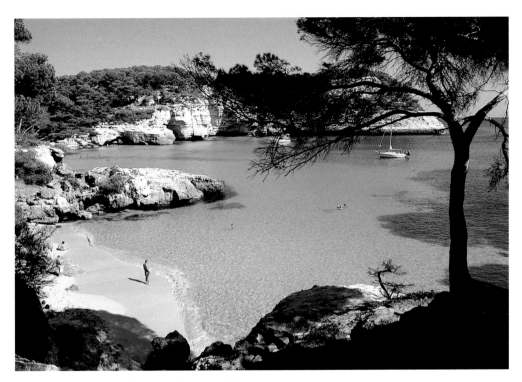

What divinity created such immaculate corners?
Which brush painted this turquoise?
Which poet described its silences?

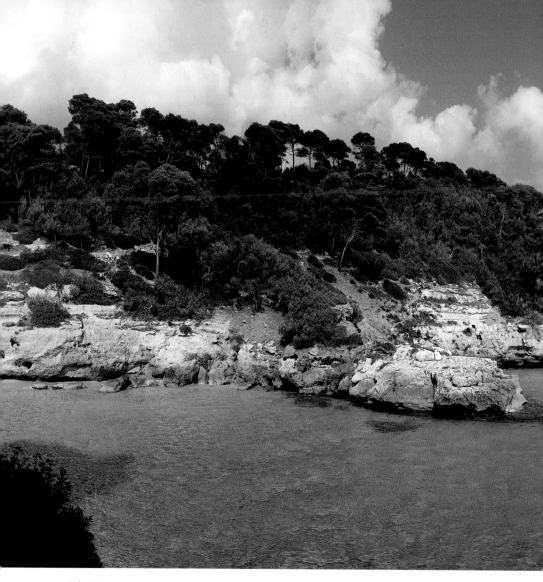

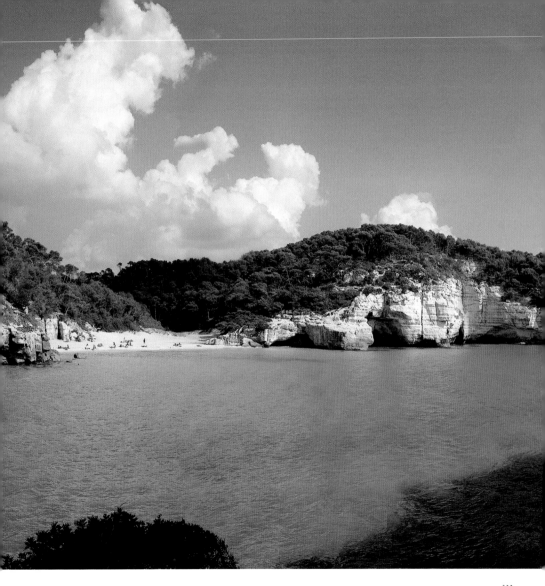

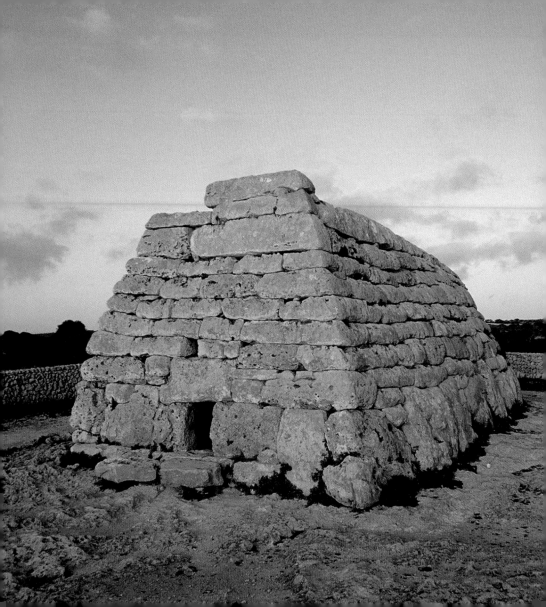

The Menorcans descend, according to the cliché, from that "good Catalan people" without comparison to any other place in the world. According to the chronicler Ramón Muntaner, Menorca was colonised by the abovementioned settlers after the expulsion of the Arab population by Alfons the Liberal, in early 1287. It is also true, however, that in 1427, when the island was in danger of becoming deserted, some criminals were settled here, accepting the pardon granted to them by Alfons the Magnanimous.

Talayotic culture, dated at around 1200 BC, within the Bronze Age, is the first truly accurate historical information we have recorded in Menorca. It showed notable similarities with other cultures from the western Mediterranean area and, in fact, survived until Romanisation. Menorca is the island with the highest density of archaeological remains from this era: *talaiots*, hypostyle halls, burial caves, walled precincts (such as that of Son Catlar in Ciutadella)..., eloquent testimonies among which feature, due to their singularity, the *taules* –monuments in the form of a T made up of two large blocks of stone, one sunk into the ground vertically and the other resting over the first horizontally– and the *navetes*, covered buildings, with a ground plan of a stretched horseshoe, which seem like a ship in an inverted position, with the keel facing skywards. The most impressive remains

Naveta des Tudons

can be found in the settlements of Trepucó and Talatí
de Dalt (Maó), Torralba d'en Salord and Torralba d'en
Gaumés (Alaior), Torrellafuda, Torretrencada, Torrevella,
Naveta des Tudons and Son Catlar (Ciutadella).

The Menorcans of today, however, have absolutely nothing in
common with the men from the Cyclopean culture. They do not
descend from the Phoenicians, Greeks or Carthaginians, however
much Nura –the island of the fires, as the Phoenicians called it– or
Meloussa –island of the cattle, according to the Greek name– had
a role in trading transactions from the 7th century BC, or that
Mago, the Carthaginian admiral, anchored in the port of Maó,
the "large port" par excellence (from here comes the etymology
of the name Maó <μα–γο, 'mega', 'magnus'). Nor did its Latin
roots come from the inclusion of the Balearics into the Hispania
Citerior province, the work of Quintus Caecilius Metellus in 123
BC. Along with the incursions of the Vandals (424-425 AD, 455
AD), we can also record the existence of early Christianity (with
the famous epistle of Bishop Severo in 417, and the remains of
Paleochristian basilicas in Son Bou, Es Fornàs de Torelló, Cap del
Port de Fornells, Illa del Rei...), as well as a Byzantine Menorca
from 513 AD until the annexation to the Emirate of Cordoba (903).

Four centuries of Islamic presence inevitably left a deep imprint
on Menorca, present even today in the place names and in some
ethnological relics such as *cuscussó* (a type of sweet couscous
made with breadcrumbs, almonds, sugar and honey, which is a
Christmas speciality), the waterwheel, etc. and diverse archaeological
remains. Muslim Menorca went through the same vicissitudes
as the rest of the archipelago, but in 1232, through the Treaty of
Capdepera, the Menorcan almoxarife (tax collector) surrendered
vassalage to King Jaume I, a situation that was maintained
until the conquest of Alfons III of Aragon, in January 1287.

Over 700 years separate us from that date on which the people of Menorca, as we form it today, experienced its founding day. Menorca was incorporated into the Crown of Aragon and that was the starting point of the Catalan identity of the island. The Muslims were replaced by Catalan Menorcans: the elegiac lamentations of some and the epic enthusiasm of others form the two sides of the same coin. In any case, it should not be forgotten, that is how it is recorded in history. And the current Menorcan people, the people that have continued until today, beginning their presence in the late 13th century, are heirs to those Catalans who made Menorca their land, thus forming a new historic space and a new personality –cultural, linguistic and human– through which they could live.

From this time on Menorca had laws and social organisation on a par with those ruling the Catalan territories of the time; Catalan was its only territorial language and also that used at all levels; the four red bars came to be the colours of its flag; when in 1463 the Menorcans rose up in arms to defend the cause of the Prince of Viana, which then represented the "autonomous" freedoms against Joan II, they did it to the cry of *Visca Catalunya!*(Long live Catalonia!)... The consciousness of Catalan identity of the Menorcans is shown throughout the centuries of rule of the dynasty of Austria and would not be dispelled except by means of a carefully planned and impeccably executed assimilation process, especially after the inclusion of Menorca into the Spanish monarchy in 1802.

During the centuries of transition to modernity, Menorca suffered terrible natural plagues –frequent droughts, bubonic plague, hunger and disease– and other no less horrific events –civil war (1451), banditry, Turkish pillaging of Maó (1535) and Ciutadella (1558), attacks by North African corsairs ... all this occurred until the point when, in 1570, Felipe II ordered the depopulation and abandonment of the island: the islanders refused. Or to put it another way if you like: the *ullastre* twisted and the *socarrell* resisted.

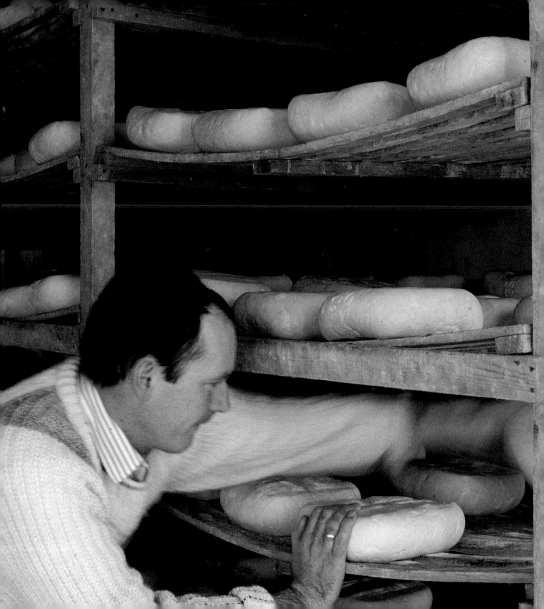

The majority of historians would like to see the history of the island as a constant conflict between the towns of Maó and Ciutadella, which would explain many tensions and expansions in the passing of time. A more rigorous analysis tells us, at least, that the confrontations between *maonesos* and *ciutadellencs*, were caused, as often occurs, by the differing interests of the dominant classes settled at either end of the island.

The influence of the landowners, who in the 17th century bought titles of nobles, was located in Ciutadella –the old capital of the island and established Episcopal seat since its restoration in 1797–, where the weight of political and social conservatism was based. This was in contrast with Maó which, throughout the 18th century, experienced its expansion in the shelter of its port; where the British governors based their residence, and which oversaw the appearance of a merchant bourgeoisie that embraced liberalism without renouncing protectionism when it was in their interests. This bipolarity is still present in current attitudes.

The positive consequences that the British (1712-1756, 1763-1782, and 1798-1802) and French (1798-1802) presence had for the Menorcan economy and culture have been sufficiently recorded. Suffice to mention the intelligent work of the government of Sir Richard Kane; the flowering of trade with many Mediterranean ports and the awarding of privateering patents, as well as the existence in Maó of a brilliant *Societat de Cultura* (Culture Society), with men of letters and scholars such as the Ramis brothers, Antoni Febrer i Cardona, Vicenç Albertí and others, who took part in a splendid period, classified by Jordi Carbonell as the, "Menorcan period of Catalan literature" (coinciding with neo-classicism and pre-romanticism).

The clichéd version of a Menorcan is a peaceful, tolerant, kind and submissive person, but we just need to look at the 19th century to

realise that there quite a lot of exceptions to that stereotype: the disturbances of 1810 in opposition to forced enlistment and new centralising measures; the political shifts between liberals and conservatives, not particularly peaceful; the emigrations to North Africa and the Americas; the awakening of working class consciousness... until the war of 1936 and the post-war period, clearly show the opposite. It is a fact that throughout history, life in Menorca has never been particularly easy and kind for the poorer classes and they have not exactly behaved as passive classes, although caciquism, and servility towards the lord and master continued where the old agricultural structure was maintained.

At the beginning of the 20th century people began to talk of a republican, left-wing Menorca as opposed to a right-wing, conservative Mallorca. This statement would need some qualification. In any case, it is true that the electoral behaviour of the Menorcan people does not coincide in all ways with the voters from the other islands. Simplifications are not generally speaking satisfactory.

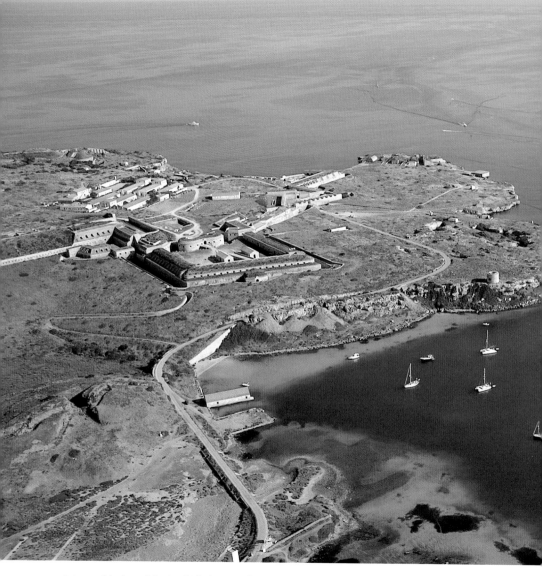

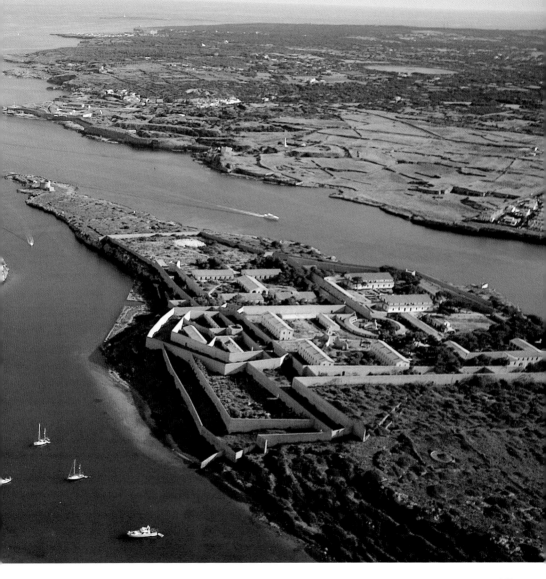

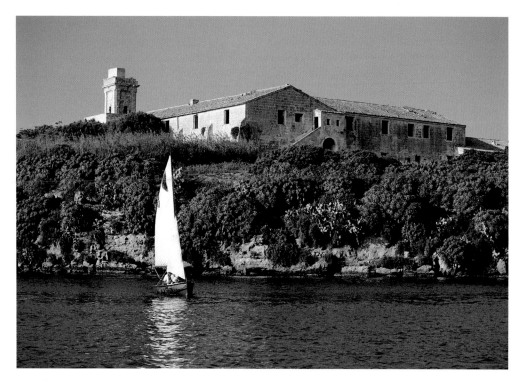

Maó

The chronicles recount that King Alfons III of Aragon sighted and landed on this island, in the selfsame port of Maó, on the first days of 1287 and that he had to wait for the ships of his fleet because the Tramontana had dispersed them after setting sail from Mallorca for the Catalan conquest of Menorca. Today one can see here the ruins of an old blood hospital and, just beyond this Illa del Rei, is that of the Llatzeret (isolation hospital). The constructions remind us of an 18th century in which the city of Maó experienced, sheltered by its port, times of great commercial and military activity. At that time, the island was an unavoidable point in the sea paths for the vessels that coursed the western Mediterranean.

The Llatzeret, opposite the town of Es Castell ➤

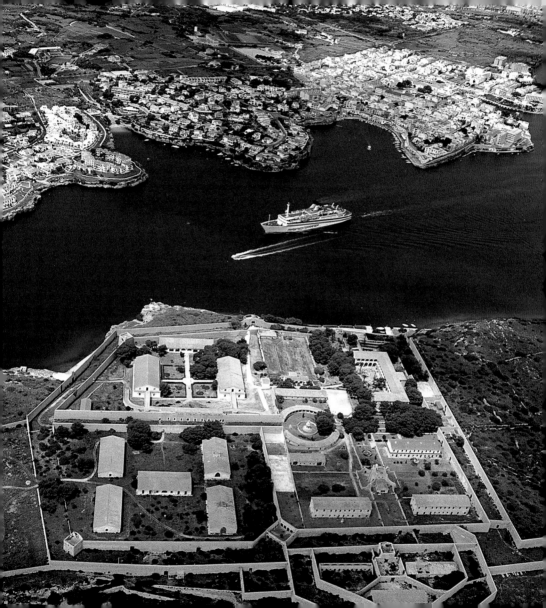

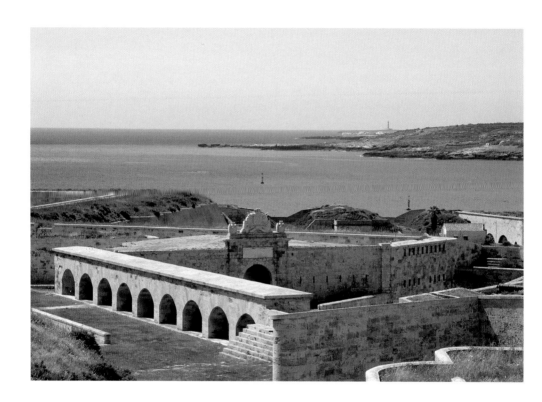

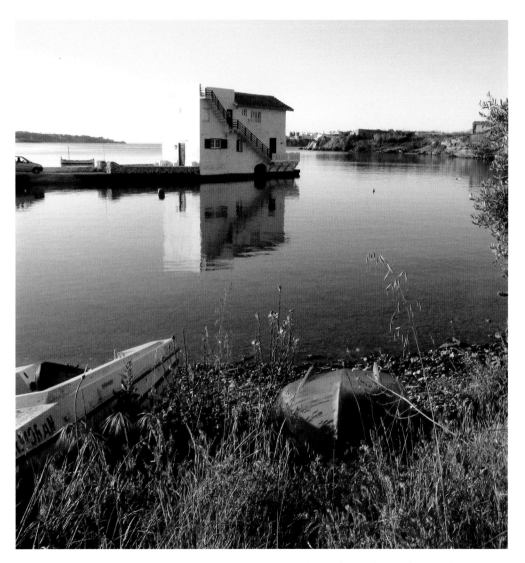

Curious house close to the port of Maó ·

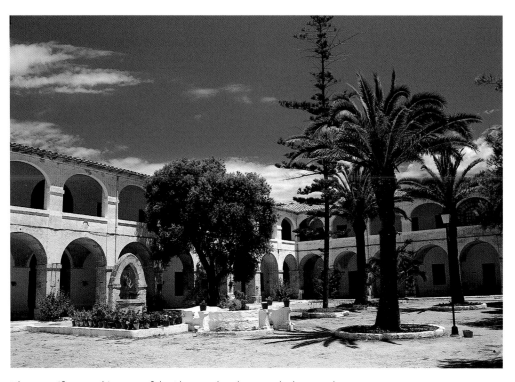

The magnificent architecture of the Llatzeret barely conceals the tragedy
of the contagious patients who perished there while they were in quarantine.

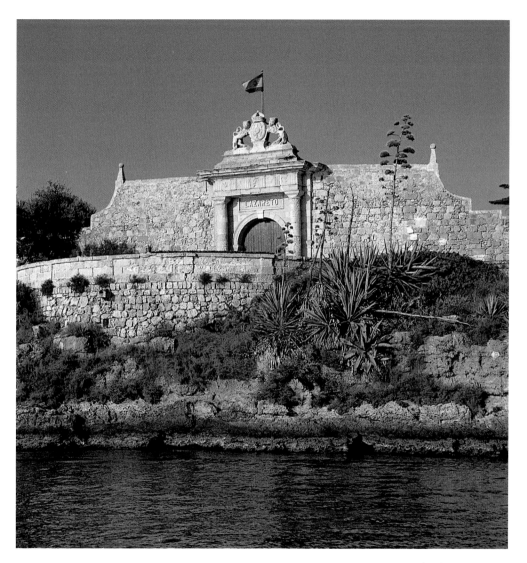

· The Pla de Baixamar marks the spot between the port and the city

The whole area is a very busy commercial centre in the summer months ·

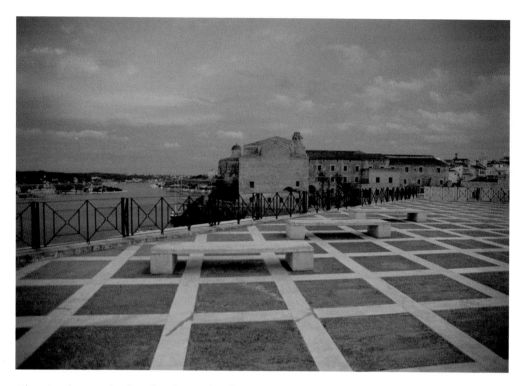

Observing the port, the city takes pleasure in reflecting upon history. Departure and arrival point. The hopes and destiny of its sons and all those who have found shelter in it.

The old city over the western jetties ►

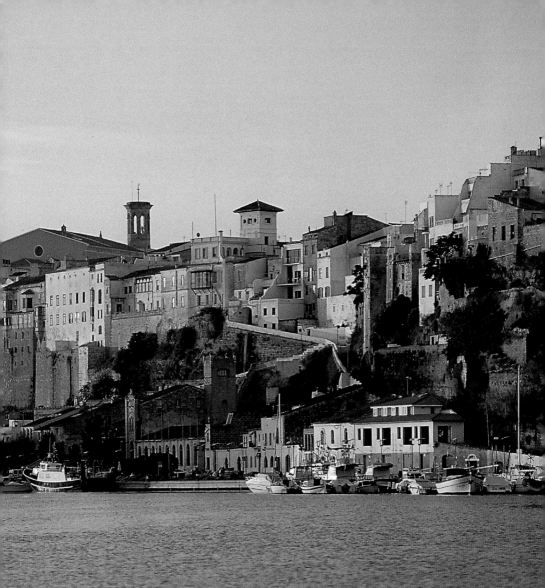

If fishing has traditionally been a world reserved for the men, the fish market was, until very recently, a stronghold of the fishermen's wives. An atmosphere of closeness and human relations. Calling the customers by their names –even when we all know each other–, it was they who had to sell the fish, a product with a quick expiry date.
–Hala, dones, gerret i mescla! Tenc gambeta fresca! Vine, Cisqueta, que et faré bon pes (Come on girls, picarel and all sorts! I've got fresh prawns! Come on Franny, I'll give you a good price).

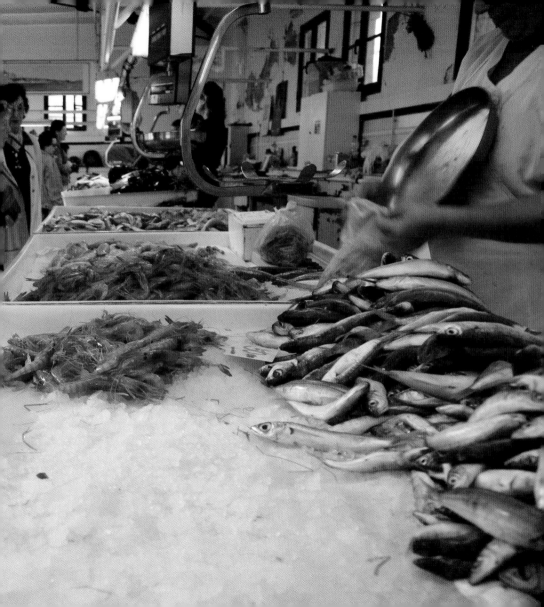

Casa Mir, of a Modernist influence · 135

Stable commerce or market stalls, as in Sa Esplanada,
invite the tourist to remember to be a consumer

Provisions Market, in Maó, in what had been the cloister of the convent of Carmen · 143

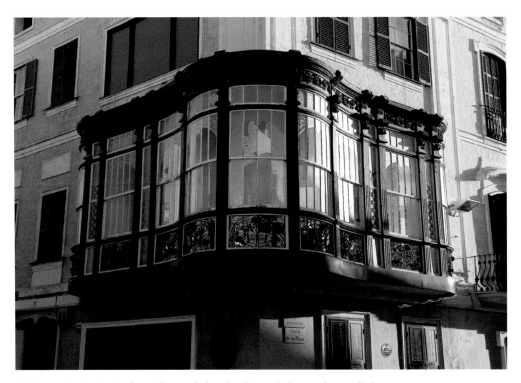

The large window in the form of a small closed gallery or balcony – here called boínder, *from the English bow-window–, was a sign of distinction of a house. The house faces the street or square in order to take a bearing on the world. From popular events, parades, processions, cavalcades of the liveliest and most serious of festivals, through to the deep passing of time, always equal, always distinct, according to the season. The curiosity for the daily spectacle behind the bourgeois discretion of the curtains.*

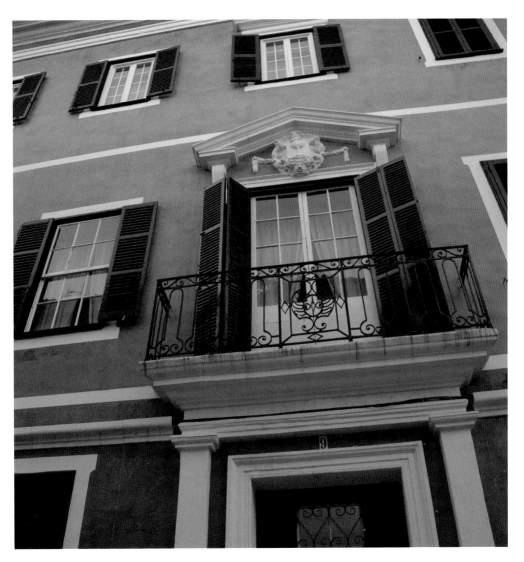

My house, our house, and if deemed so, your house too. Free entry to the friendly neighbour whenever need be. Nobody will be denied bread and salt. The door to the welcoming home, handles polished with devotion by the lady of the house.

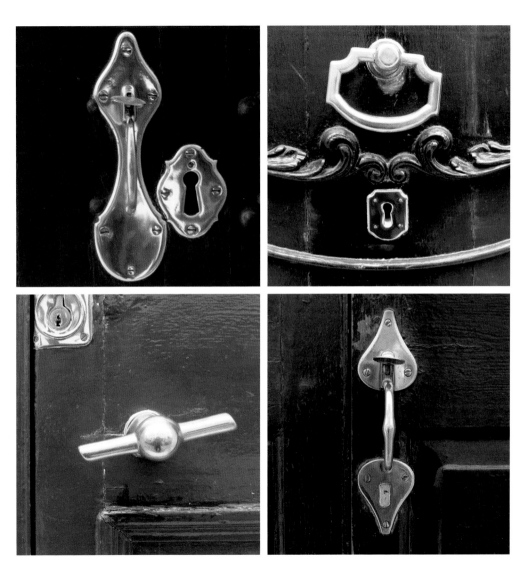

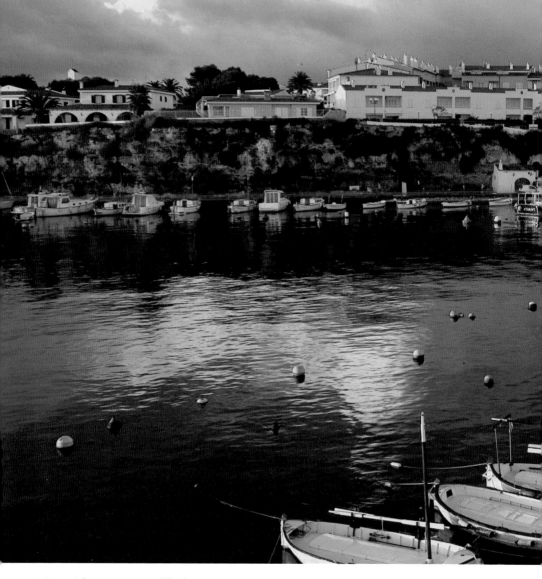

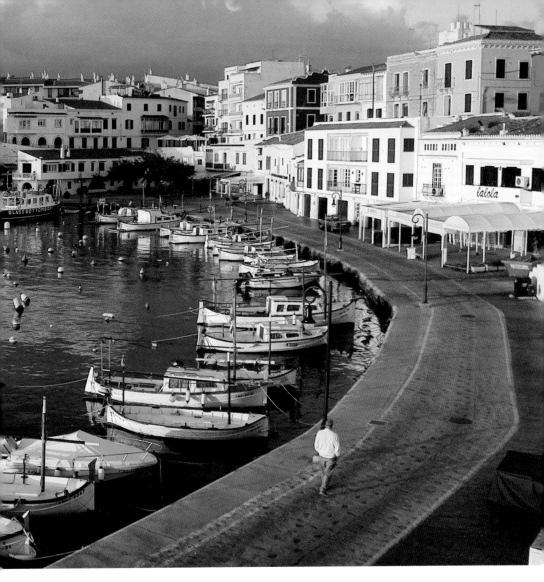

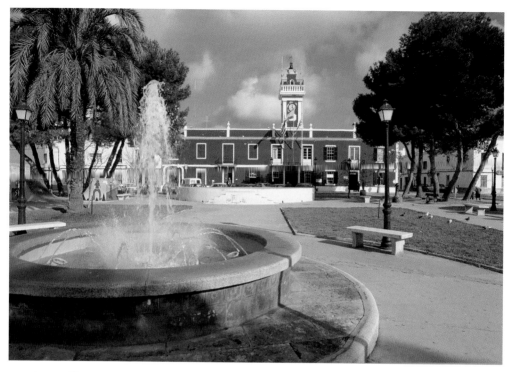

Es Castell

In the suburb of the castle of Sant Felip, which protected the port of Maó, a settlement was established that the English called Georgetown and which became Villacarlos in Spanish when the waves of history resulted in the island, after eighty years of British domination, passing into the hands of the Spanish, from the name of His Majesty of Britain to the Bourbon King of Spain, but the Menorcans disregarded both and have always called it Es Castell (the castle), without complicating things. The urban expansion, hastened by immigration in the last third of the 20th century, has made this town grow until reaching the boundaries of Maó; its inhabitants, however, have maintained until the present a highly differentiated personality.

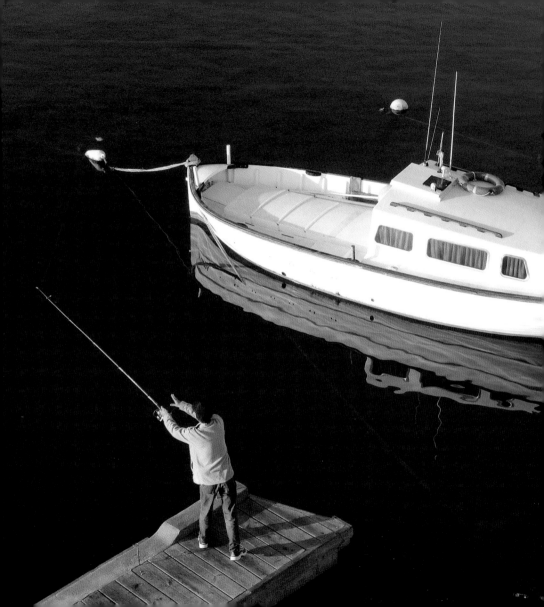

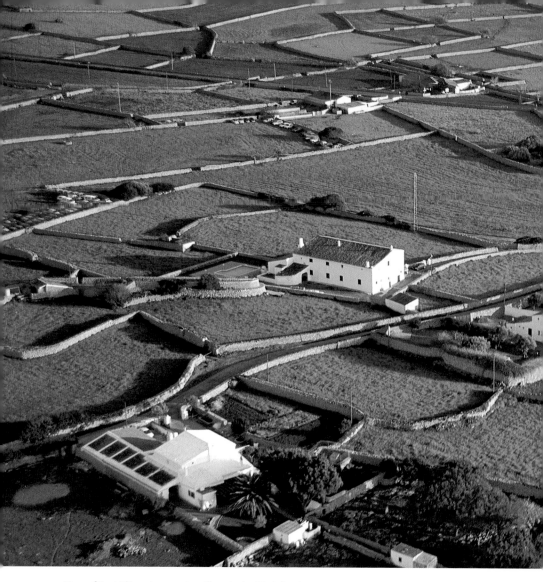

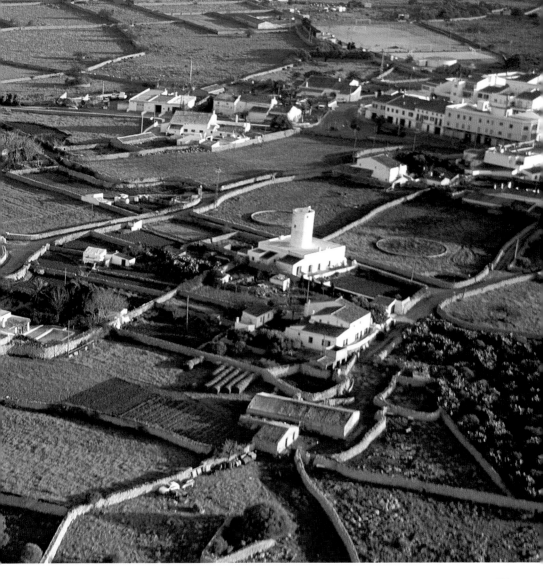

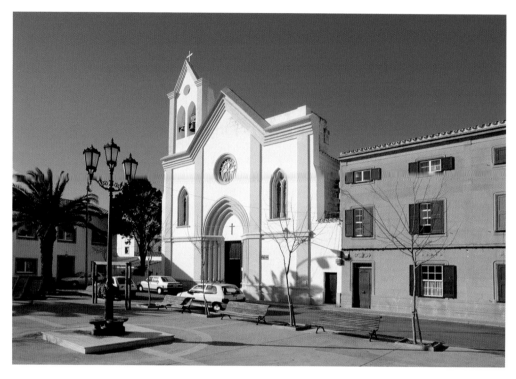

Sant Climent

The population of the eastern island is disperse and spread around many villages and country houses due to the fragmentation of farmland and the type of agricultural exploitation. A humanised landscape in which it is feasible to enjoy a simple and homely life, between the intimacy of the isolation and the security that friendly neighbours provides. Outstanding here are the villages of Sant Climent and Llucmaçanes, in the district of Maó, and Torret, S'Ullastrar and Es Pou Nou in Sant Lluís.

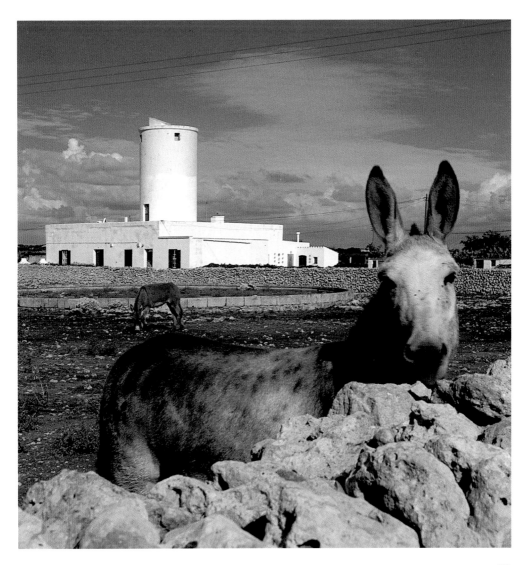

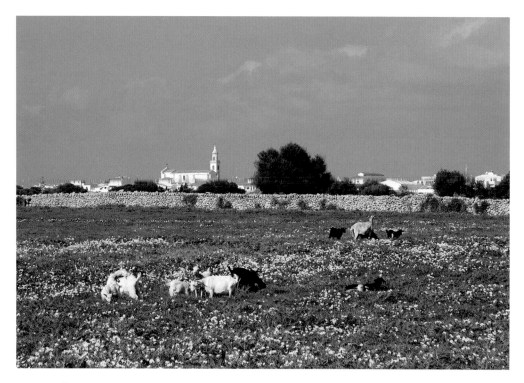

Sant Lluís

The whitest of all, Sant Lluís was founded as a rationally designed town by the French in the time in which the island remained under the control of Louis XV's fleur-de-lis. The concentration of the disperse inhabitants that its founders aimed for, has been reversed with the change of century, when urban expansion has transformed the picturesque eastern and southeast of the island (S'Algar, Alcalfar, Punta Prima, Binisafúller, Binibèquer) into a powerful tourist area.

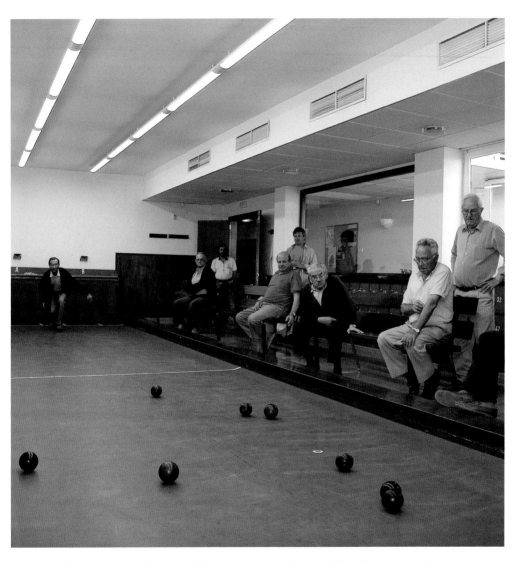

Residents of Sant Lluís playing *la bolla*, an indoor game which is old but which has a loyal following ·

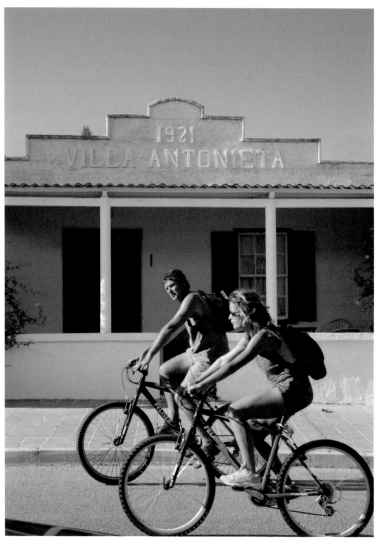

Alcalfar, in the southeast of the island, was one of the first places where tourism began to make its presence felt

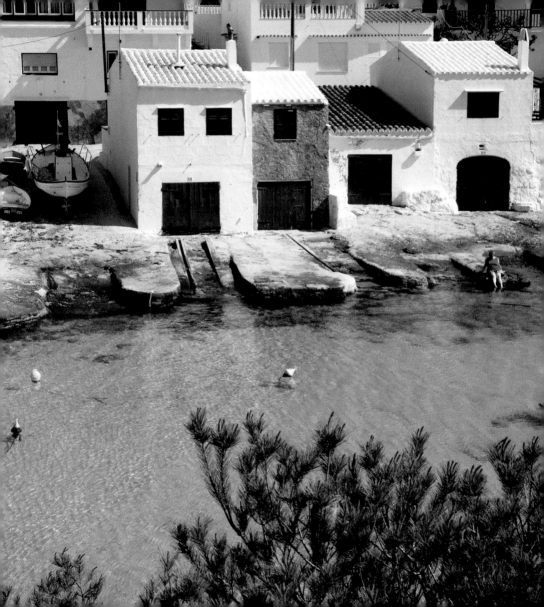

Those currently living in the houses of the old country villages appreciate
their simple beauty and enhance their more traditional elements

Tourism has not always resulted in the loss of charming spots. In Binibèquer (Sant Lluís), a curious architecture of simulating the popular –a presumed "fishermen's village"– managed to recreate quite an original version

The seafaring atmosphere, whether old-fashioned —as can still be found in some hidden corners— or imitation, requires a palette full of blues

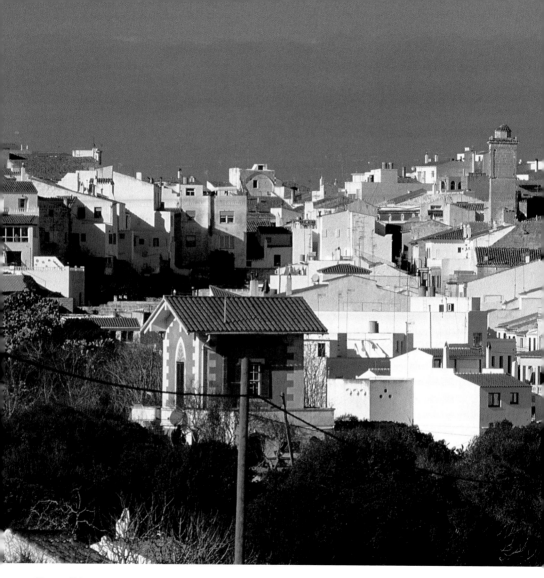

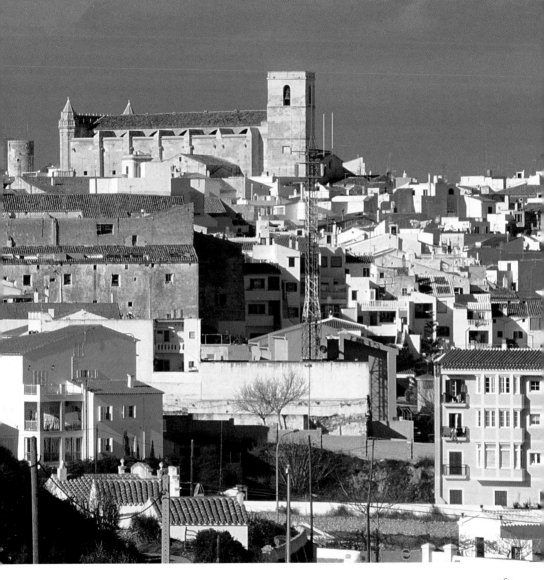

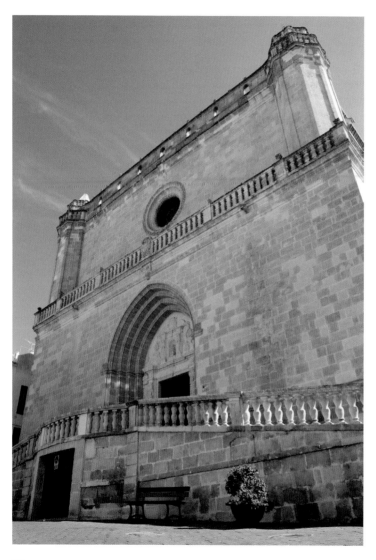

Alaior

The imposing building of the parish church of Alaior, diminishes even more the houses that were already there or were built at the same time. The soul needs more space than the body

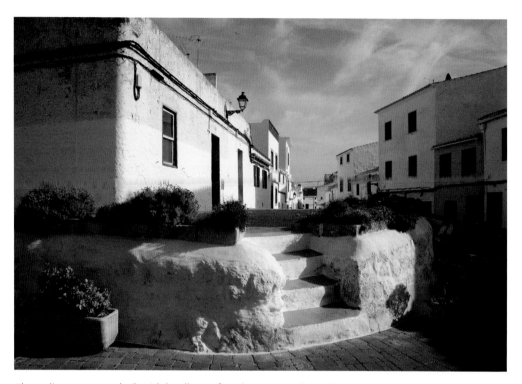

The earliest structures, built with hardly any foundations, raised directly over the stone, were replaced by a bourgeois architecture: at the same pace as the local population evolved

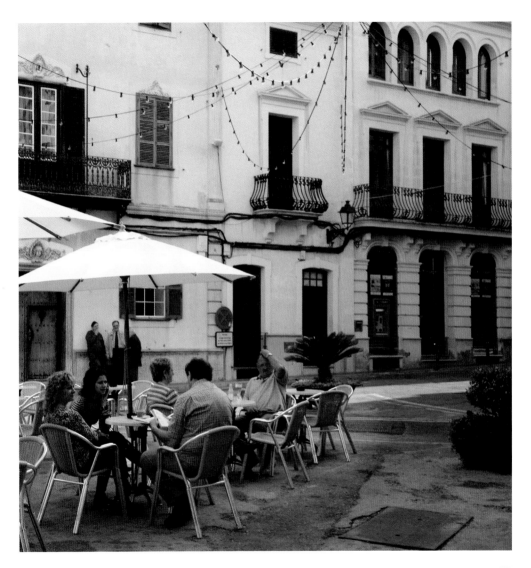

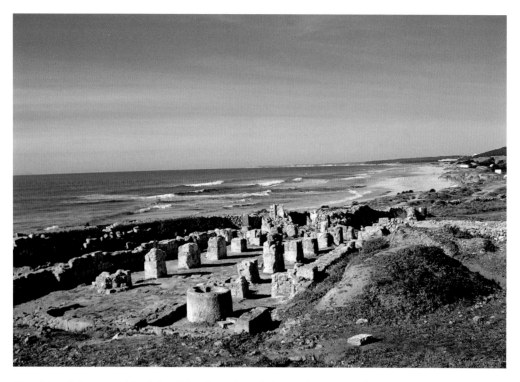

The trinity of sky, sea and land that Saint Augustine tried to produce on North African beaches, and it was as impossible to understand the mystery as it was to empty the sea in the baptismal font of the basilica of Son Bou. From the Paleochristian remains to the medieval theological perspective, with the church of Santa Eulàlia overlooking the town of Alaior, the voice of the Bishop of Hipona advises us not to go outside, but to travel in our inner selves in order to discover the truth. Like in a stroll around the silent streets of Alaior ...

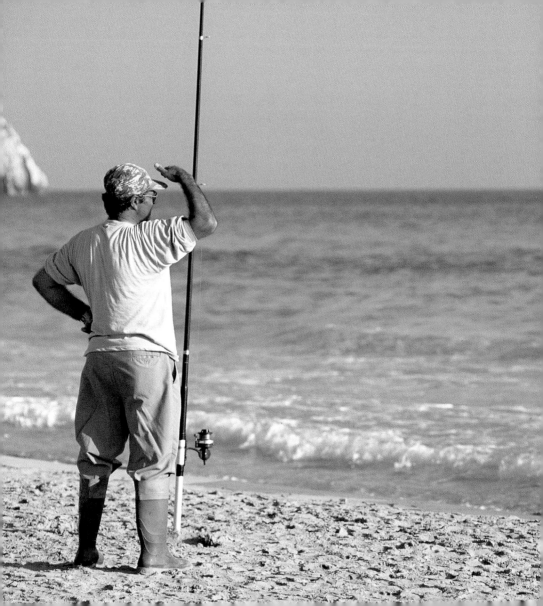

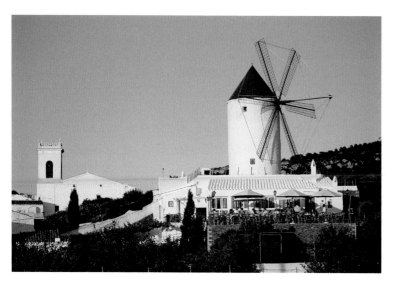

▶

With Es Mercadal
at its feet, El Toro
centres the island's
geography

Es Mercadal

From sky to land, verticality: the Toro and at its feet, Es Mercadal. In the final stages of the 13th century, King Jaume II awarded it the privilege of being a market centre and, today, it has strongly recovered this character of a meeting point due to its location. Here we are in the very centre of the island, where the merchants sell priceless products at a good price: calm land breeze of the orchards, fields of honest cereal and generous pasture, rugged-looking hills (although others, however, are rolling and green), crops that require patient agricultural labour, friendly chitchat of tough and ripe words –suitable for glosats (1)–, witty anecdotes and events, noble-hearted honey, large loaves of happiness, magical herbs, legendary shovels for baking tales, remedies against scepticism, prayers for the non-believers ... The weighed up acts go to the millstones and they make honourable flour with them, which will later be virtuous bread, good for eating when kindly shared ...

1

glosats: rhyming compositions with musical accompaniment which is improvised in the few festivals that the rural folk hold; they are often humorous and usually turn into bloodless struggles between the participants

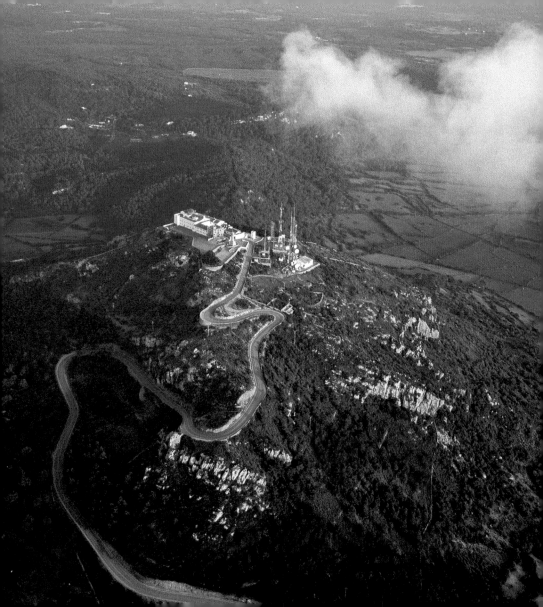

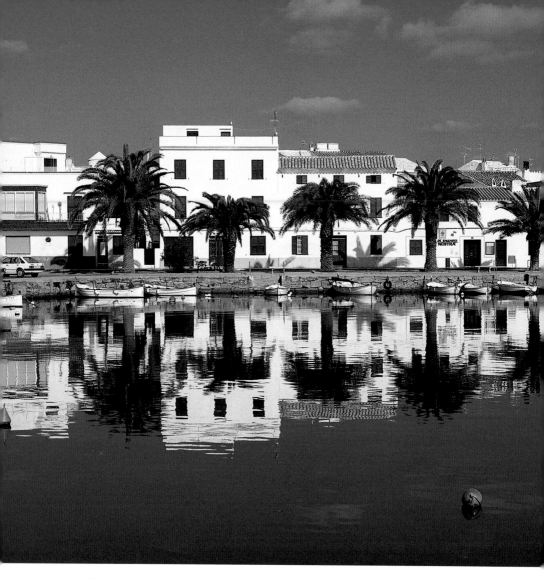

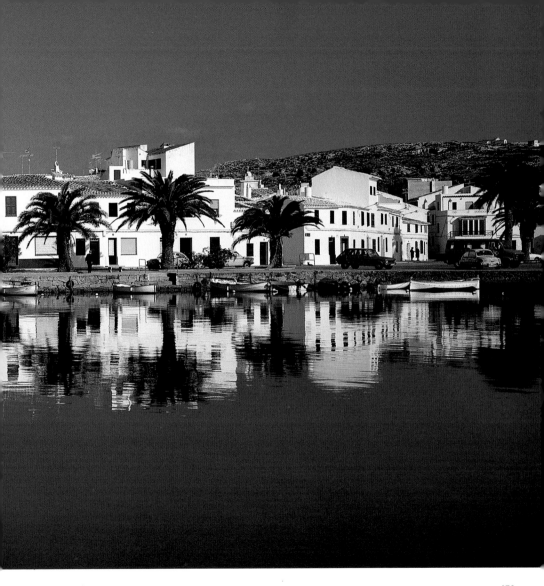

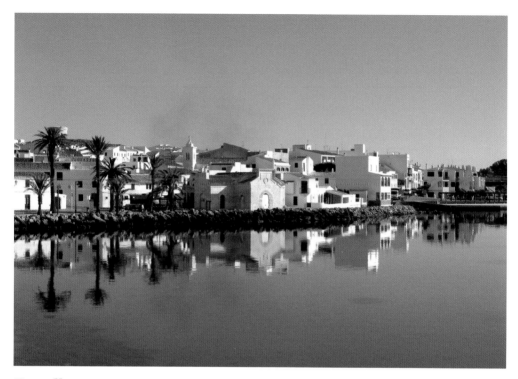

Fornells

In the north there is a rugged coastline and there is Fornells, the white town
of coral and mother-of-pearl. Nets that smell of seafood and algae. Purity and
sharpness of the air. Under the blue sky, the mirror of the water: the palm trees
swing –up and down– and the light, and dazzling whiteness of the sails and the
oars and the houses. You'll get up very early, setting a course to Tramontana,
holding firm the helm of the rudder and, if necessary, luffing.

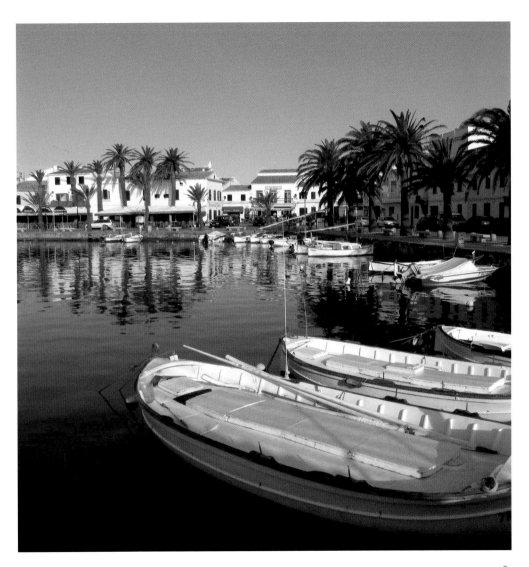

· The bay of Fornells is an ideal spot for learning water sports

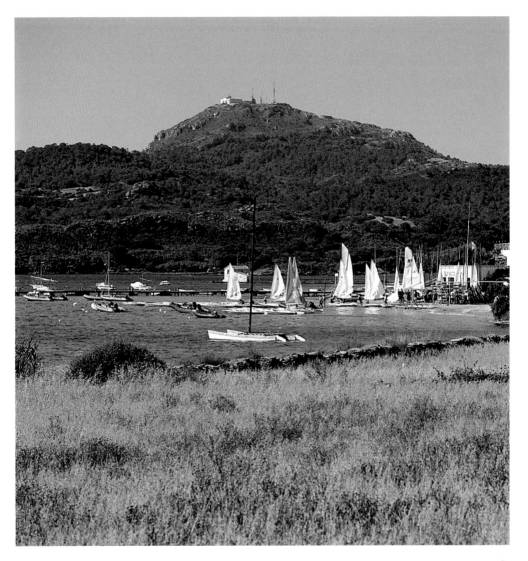

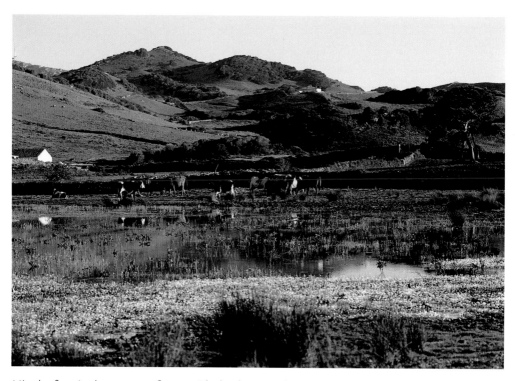

Miracle of retained water year after year. The hard-to-come-by rain is a gift of life for the driest Mediterranean spaces.

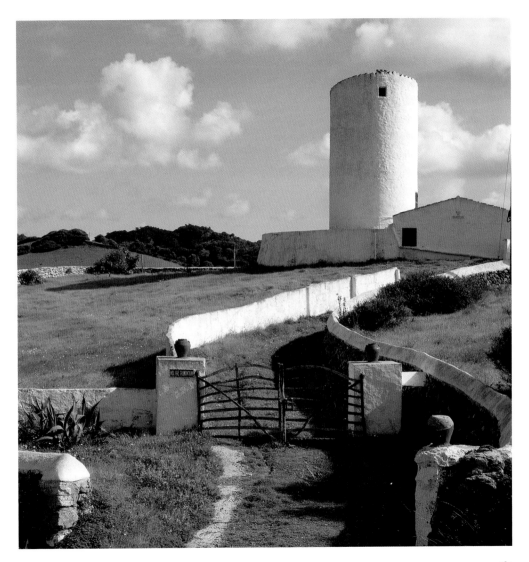

185

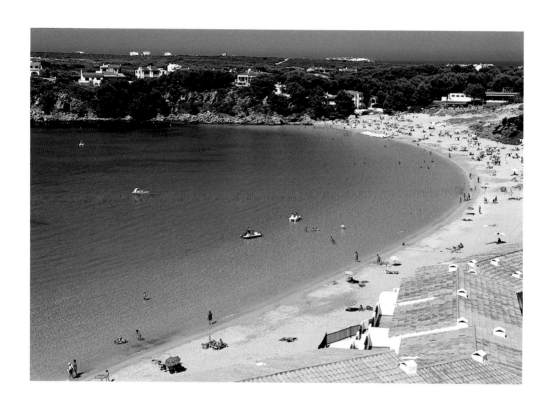

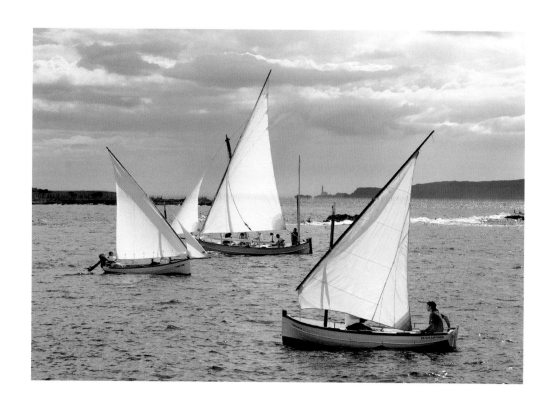

Recreational navigation is possible all along the coast, but you should
not venture too far away from safe shelters such as that of Sanitja

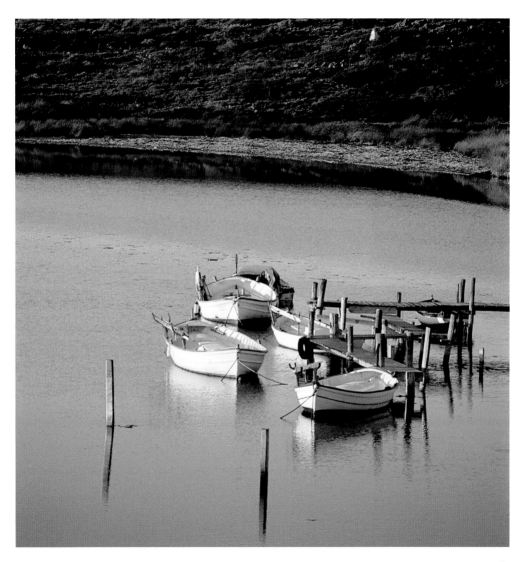

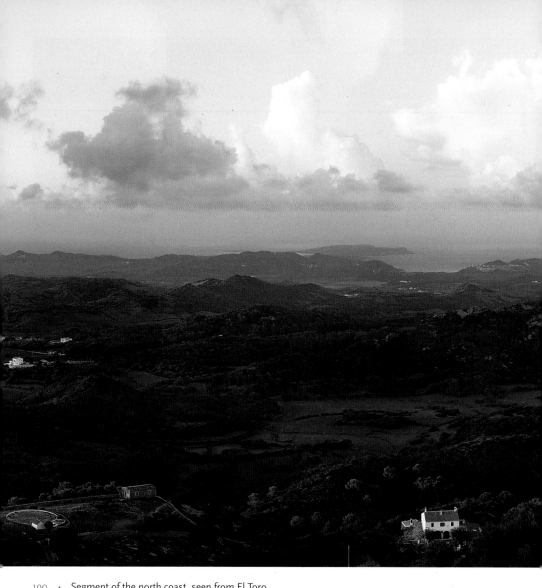

Segment of the north coast, seen from El Toro

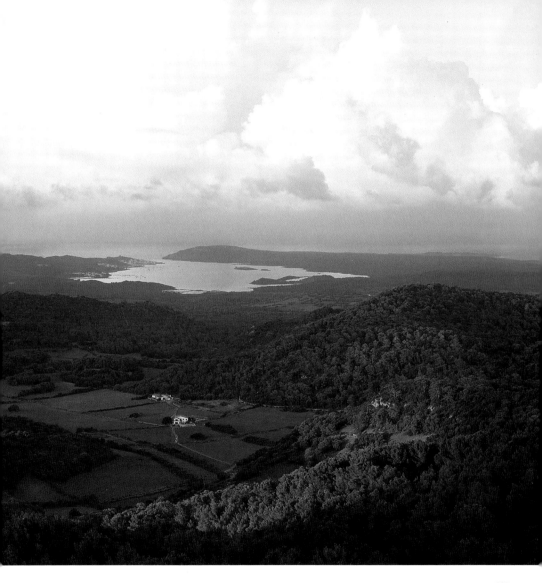

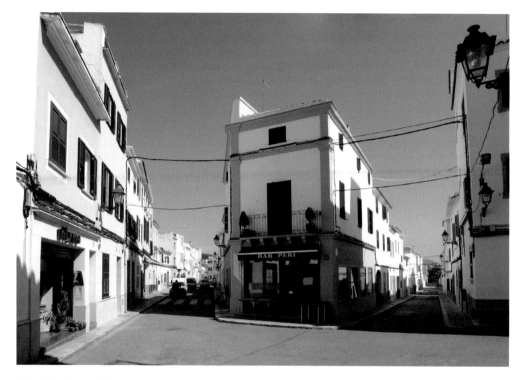

Es Migjorn Gran

*The soul of the land, the songs of the people, the treasure of the ancestors...
the body of folklore in Menorca was harvested in Es Migjorn Gran, where it still
survives. Sant Adeodato, Sant Tomàs, Sant Agustí, Santa Mònica... The place
names recall the major establishment of the Augustine friars, from their convent
in the Toro to the properties of Binicodrell. Es Migjorn Gran is the youngest
district of the eight on the island (it was formed in 1989).*

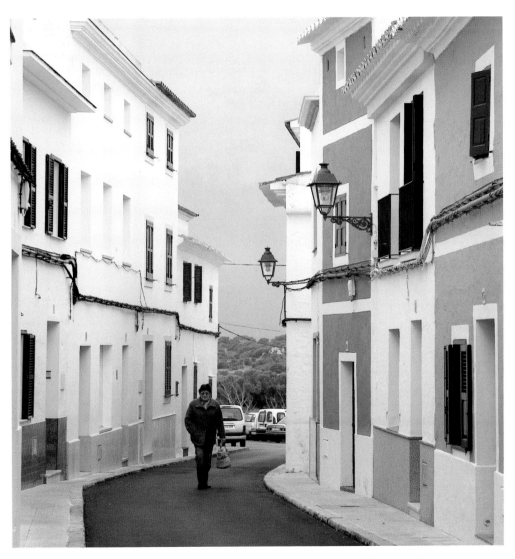

The town centre of Es Migjorn Gran conserves many of the early village houses ·

The ornamental gardening is often as simple and functional as the architecture it decorates

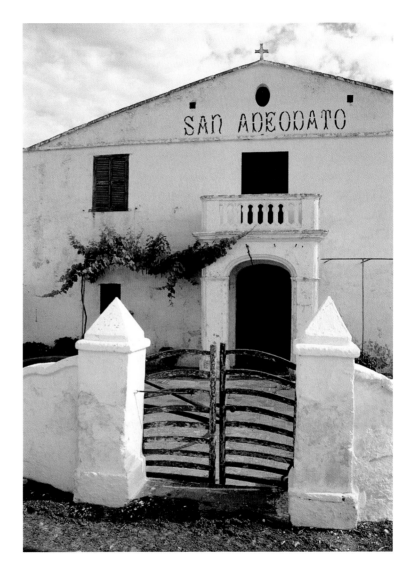

Typical entrance
to one of the *llocs*
(properties) of the area

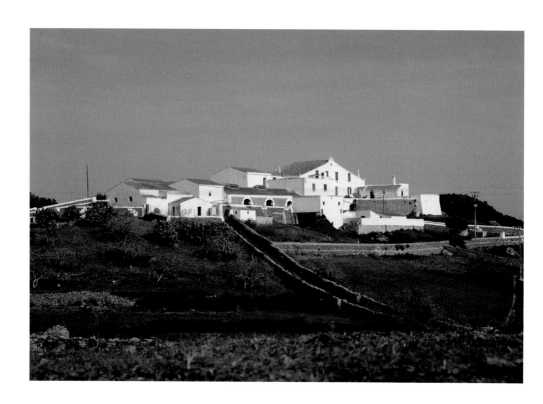

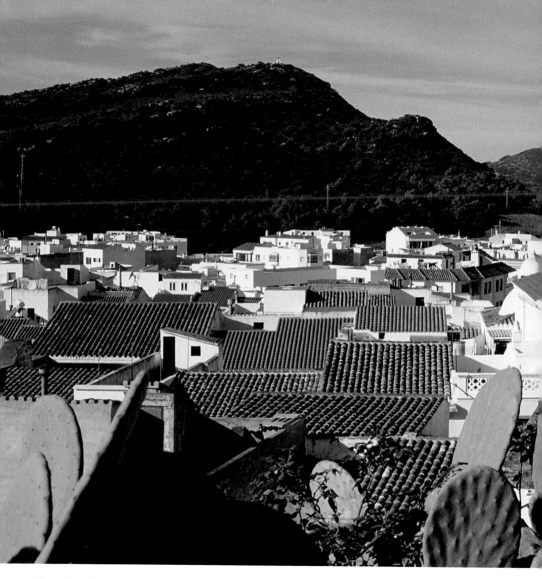

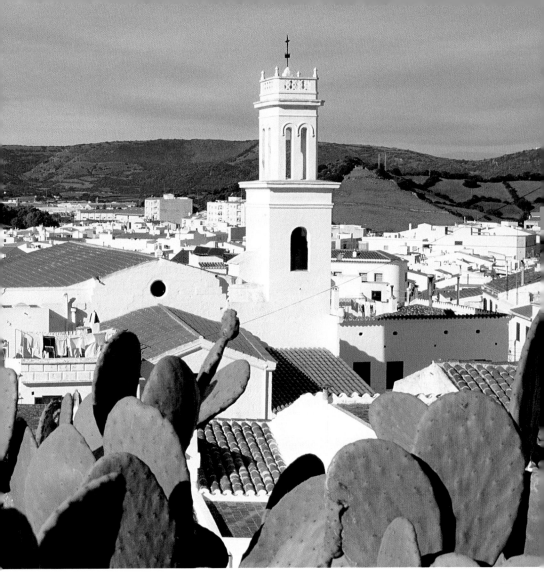

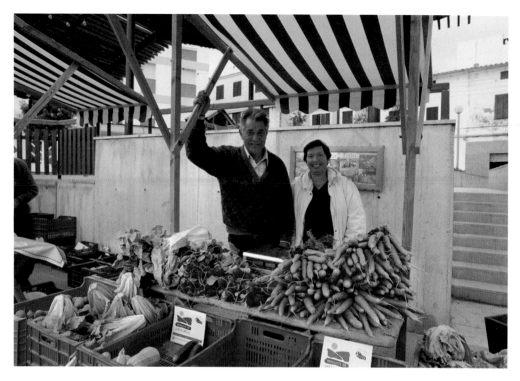

Ferreries

If anyone asked which Menorcan town is the youngest and most dynamic, many would say Ferreries. Agricultural par excellence and very jealous of its natural setting (the Algendar ravine, the Santa Àgata mountain, Ets Alocs on the north coast ...), over recent decades it has experienced a grand transformation towards industry and tourism (with Cala Galdana as a reference point). The town has a social fabric of associations that drive quite an intense social, economic and cultural life. Is this the reason why it is the highest town on the island above sea level?

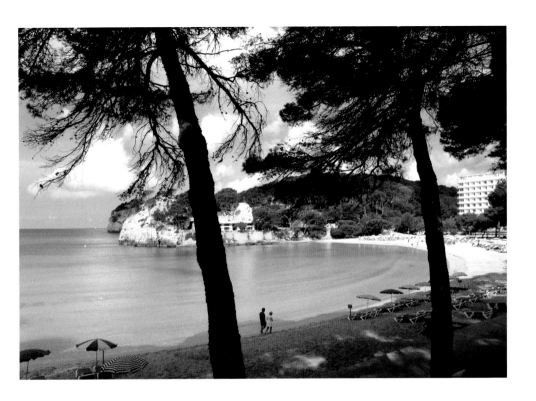

Around its parish church, the old town of Ferreries maintains the charm of yesteryear

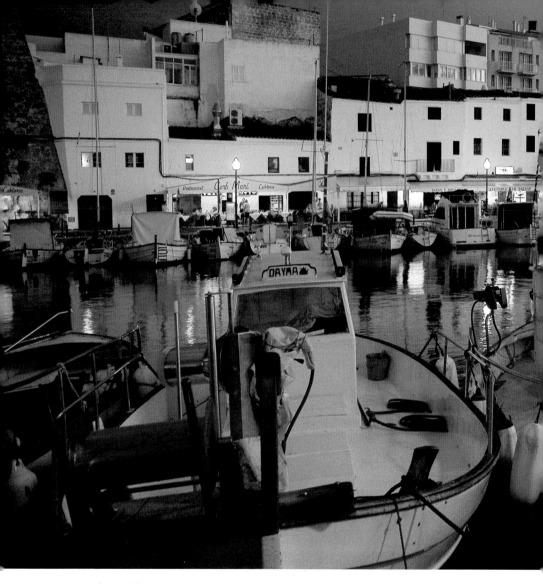

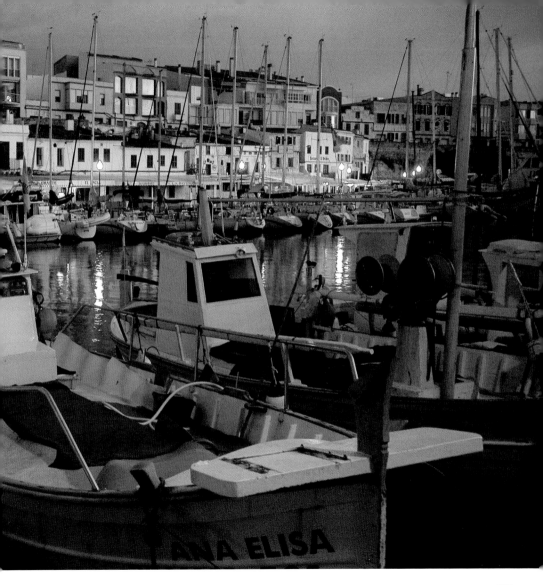

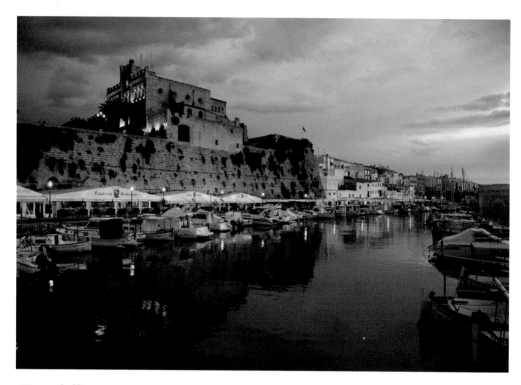

Ciutadella

The port of Ciutadella is today a big tourist attraction, more suited to man than trading ships. A safe shelter in a domestic sea that bubbles with colour and life, a contrast of light and shade, which vibrates with the hard-working haste of the fishermen and the visitors wandering around.

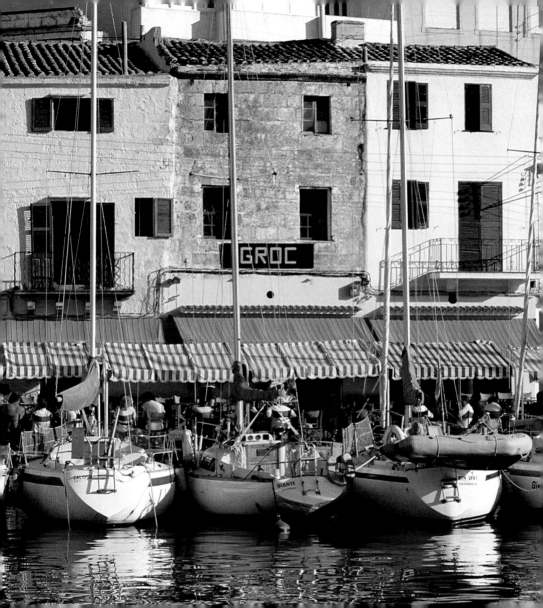

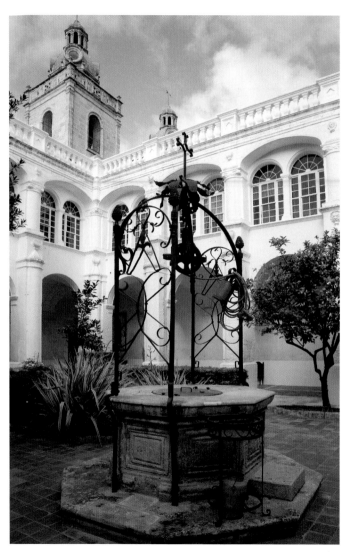

The varied architecture presents a surprise round each corner when roaming around old Ciutadella; some corners, moreover, have a really special atmosphere, such as the cloister of the old convent of Socors

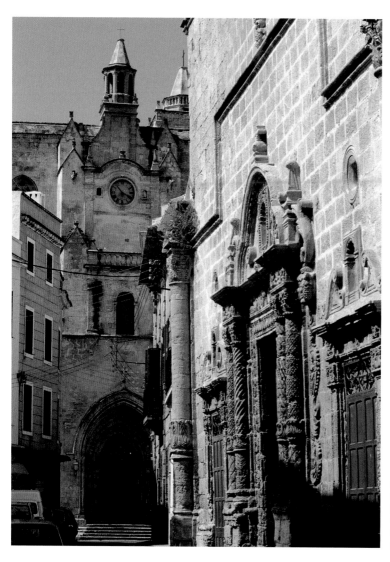

Churches and convents
alternate with the stately
houses, buildings all
of which by definition
must be higher than the
neighbouring roofs

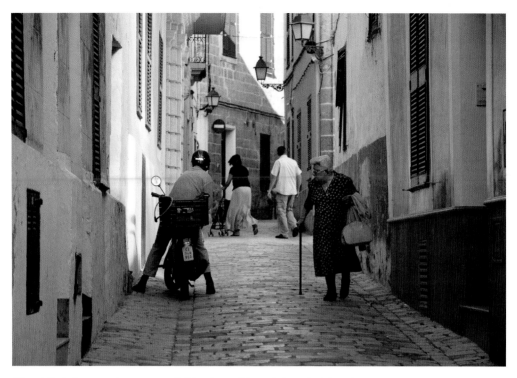

Ciutadella belongs to the category of cities that, without being administrative centres, bears the patina of distinction. It possesses notable historical legacies (not in vain was it the capital city until the 18th century) and maintained the tradition and with it the weight of a class society, governed by the landowners and by clerical power, until well into the 20th century. Its urban layout is like an open book that tells us all about it; the same occurs with the most "chivalric" aspects of the Sant Joan festivals. Time seems to be condensed and accumulated, but the years do not pass in vain and the tradition is only revitalising when it is shown in a creative way and is capable of taking on the challenges of modernity.

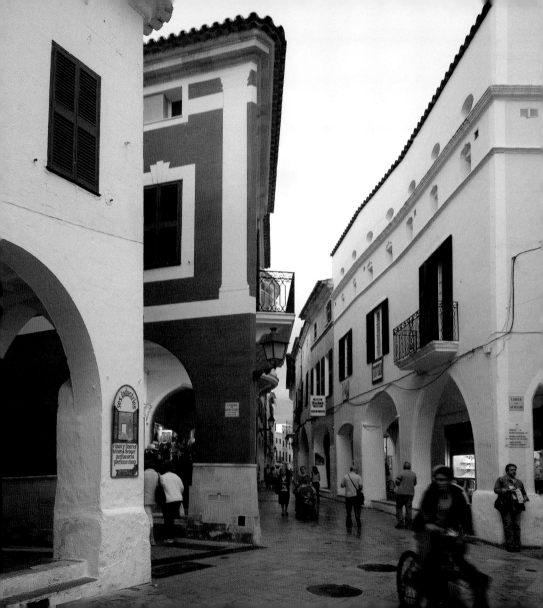

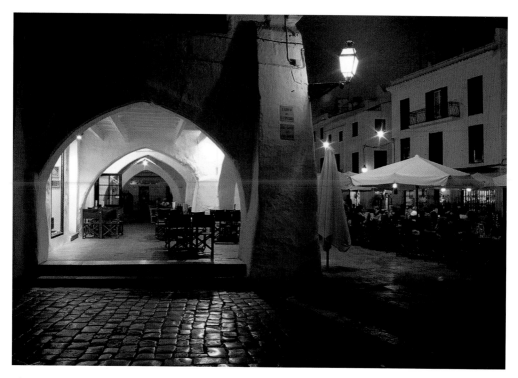

The city centre, magnificent in its ancient diversity of styles and forms, gives the impression of having a strong cultural and craftsman's air. Despite this, the population of today, with a rural, traditional and conservative soul, reveals another pragmatics and attracted by the immediate material interests, which are fed by tourism, construction, commerce and industry.

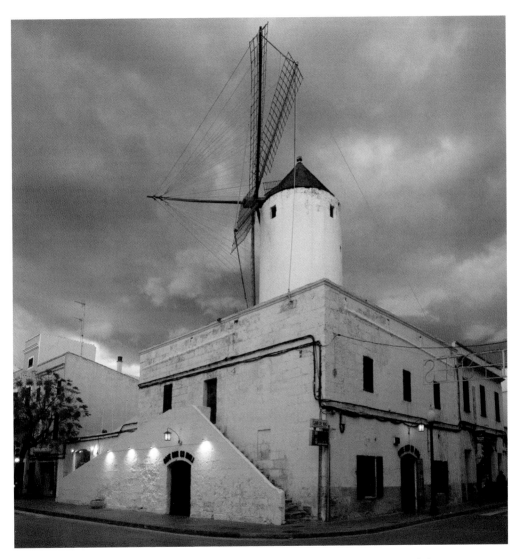

In Ciutadella, the marès, the porous stone capable of being a sponge with the rainwater and almost the only building material on the island, has an intrinsic value. In the obelisk, in vaults and columns, in corbels and sculptures, milestones, defence and watch towers, churches, palaces and humble homes... the marès is present giving colour to the town, which transmutes according to the light at different times. You can also make out its origins: from the orange tones of the quarries in the south to the greys and greens from those in the north.

The Lithica Association has recovered some of these spaces, such as the S'Hortal quarry, now used for cultural and leisure purposes

· Typical bakery and cake shop products are still prepared in the traditional way

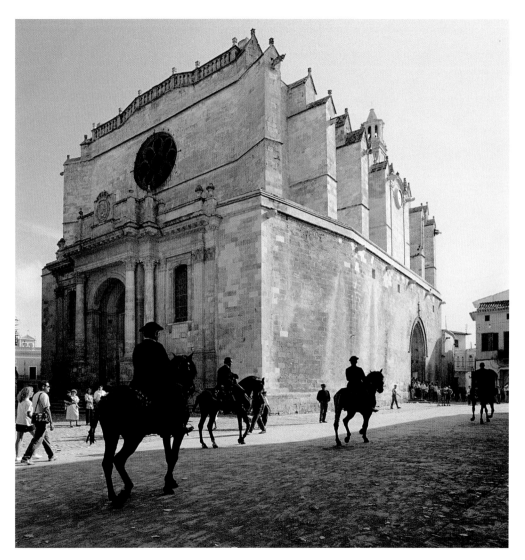

The horsemen that star in the festivals, *caixers*, passing before the cathedral ·

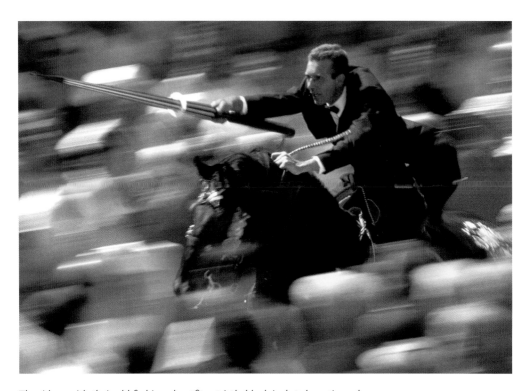

The riders, with their old-fashioned outfit –strictly black jacket, bow tie and guindola (two-cornered hat)–, carry out the traditional equestrian sports, of medieval origin, amidst the people. 24 of June: the year is of less importance. Imaginary mirage: they seem far away from this age that stirs all around them. And what can be done to eternalise the exultant joy of the crowd?

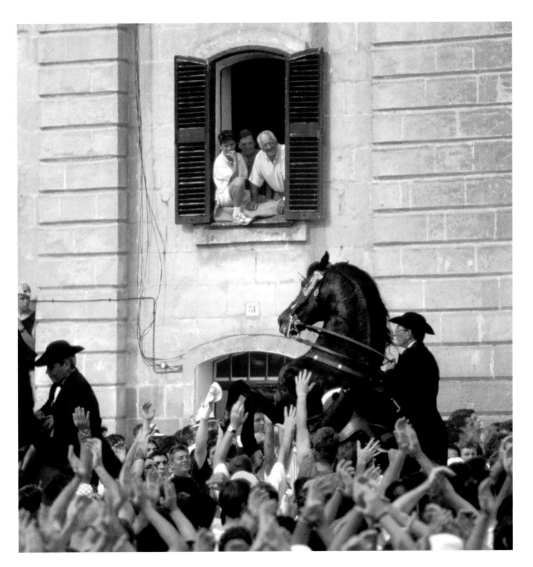

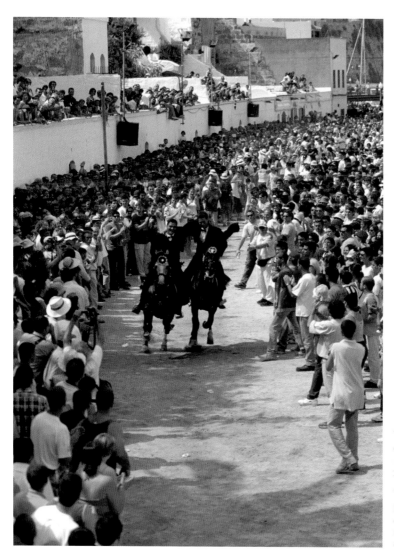

◄

One of the events undertaken in the Pla de Sant Joan

►

Hermitage of Sant Joan de Missa, a setting of religious fervour that enlivens the festival

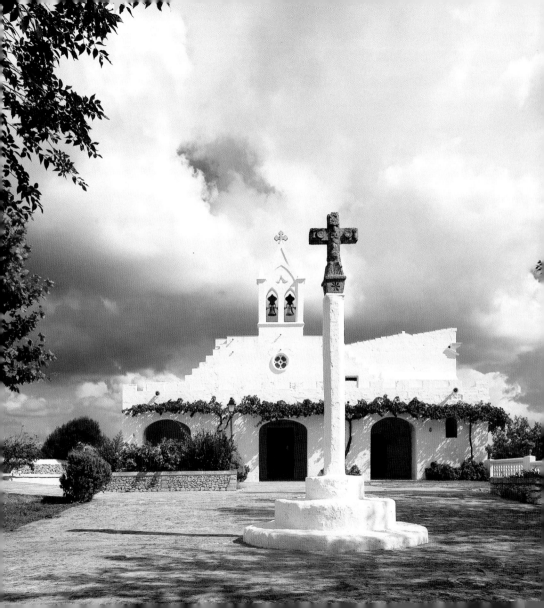

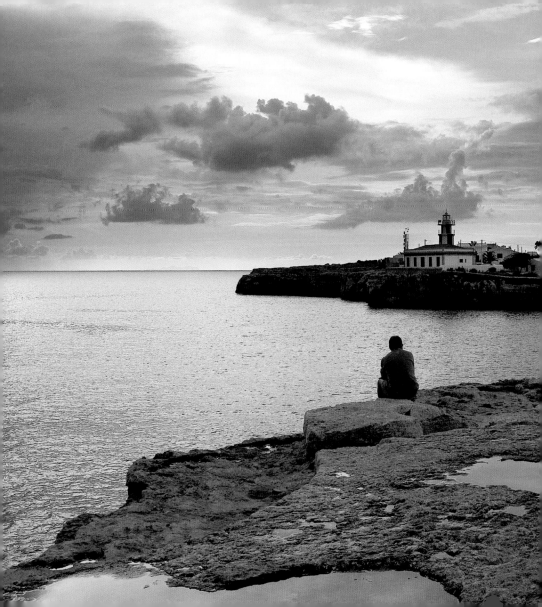

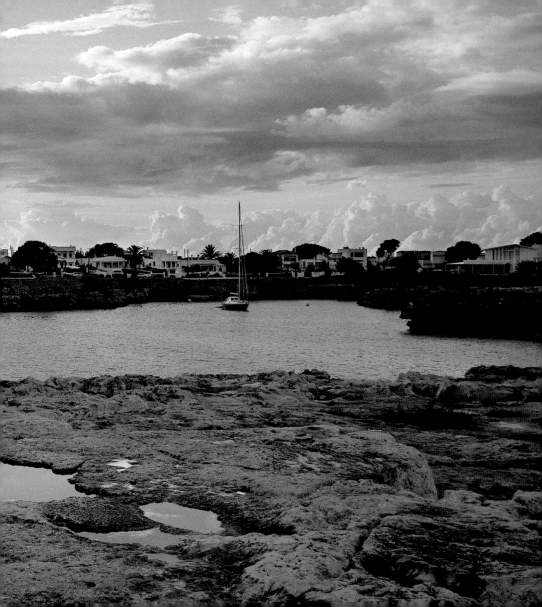

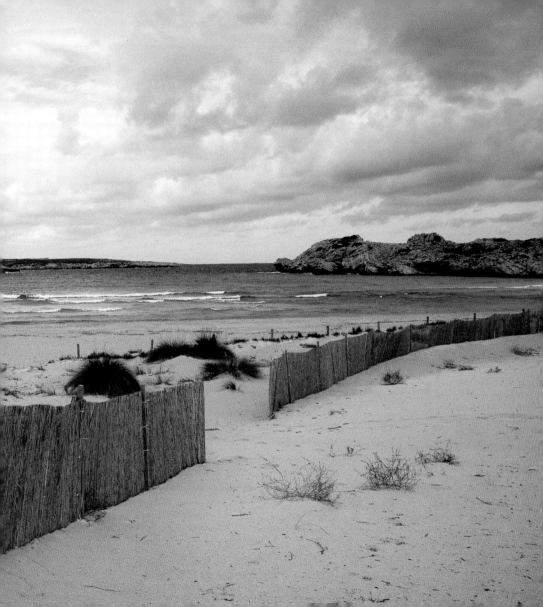

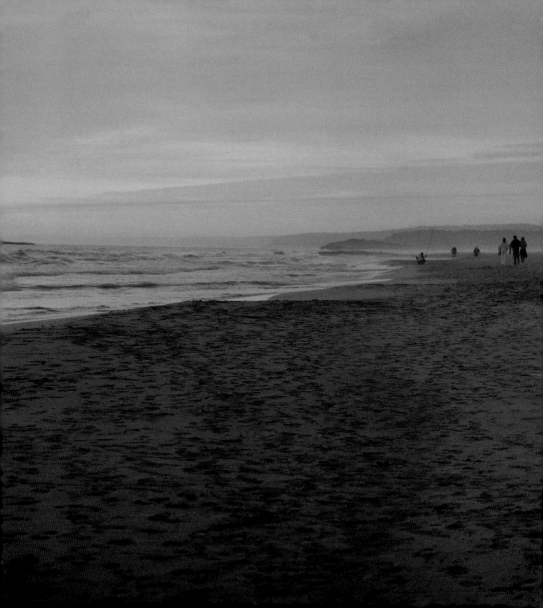

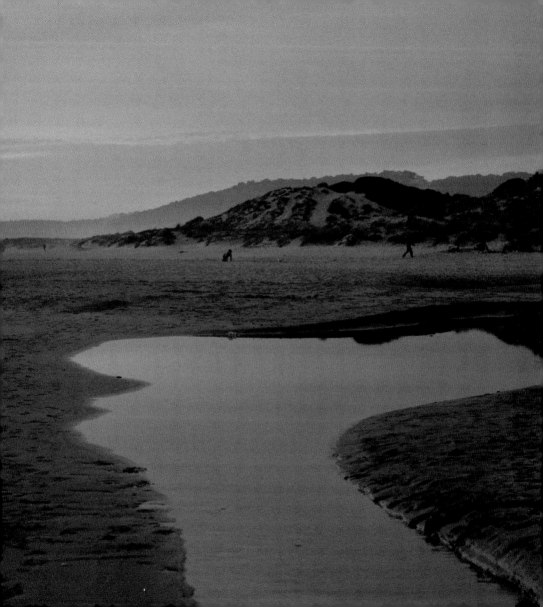

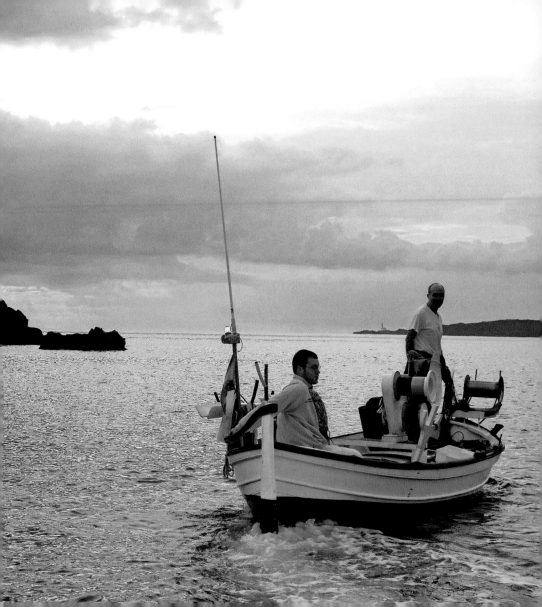

I n 1993, Menorca was declared a "Biosphere reserve" by UNESCO. This declaration is not only a recognition of the environmental values of a territory, but also represents a development model compatible with nature conservation and is, in reality, a commitment to harmonious management of the territory and its resources. For the public authority that it has been awarded to, it represents the implicit acceptance of the philosophy of sustainable development, a model based on the search for paths of progress that are not aggressive to their natural environment. According to the experts of the "Man and Biosphere" programme (MAB-UNESCO), Menorca has a harmonious, ordered landscape, with an integrated relationship between cultivated fields and natural vegetation; the island's environment is seen as an example of the possibility of coexistence between exploitation of land and nature conservation.

The economic changes of the last third of the 20th century were profound, with a very direct effect on the state of the environment and social behaviour. The evolution has been and continues to be very fast indeed. It sometimes gives the impression of a runaway horse, despite the territorial regulations; and this occurs, in fact, on the island of the horses, where strict protocols control the events –*caragols, jaleos...*– of the popular festivals.

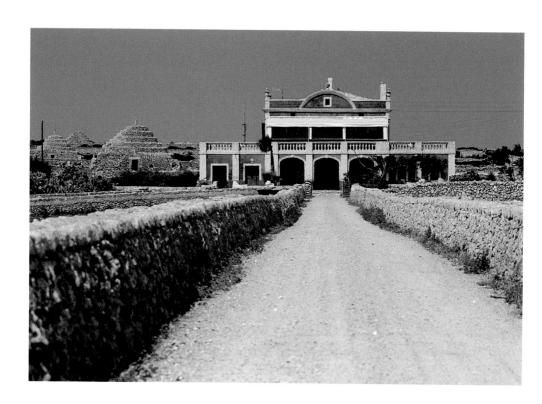

In economic matters, the growth of the third sector has been fast, especially since 1984. Menorca, therefore, has been "balearised", following, with a few decades delay, the same path taken by Mallorca and Ibiza and Formentera. The economic structure of the sixties and seventies, which provided a model inter-sectorial balance between agriculture, industry and tourism, has disappeared. Demographic growth, slow but sustained, resulted in a population of seventy thousand at the beginning of the 1990s. It is currently 86,000 with a maximum of 200,000 in the peak season in summer. Seasonal unemployment, the black economy –which has a long history–, and one of the highest rates in the State for leaving school as soon as secondary school is completed (with the resulting low rate of university students), are worrying signs of precariousness.

In contrast, Menorca has a wonderful historical, archaeological, scenic and cultural heritage, but its conservation is threatened. Despite the fact that it still has a very rich variety of flora and fauna, its maintenance was associated with the island's agricultural and livestock exploitation model, and since this has collapsed, some aggressions against the ecosystem have occurred, unfortunate events that in specific cases have had irreversible effects on the coastline, dunes and marshlands. In any case, the fight against the degradation has also had positive results: the abovementioned declaration of the "biosphere reserve" has certainly helped and has also made another kind of tourism a possibility.

Nevertheless, the island ecosystems are so fragile that we must take emergency measures. Even if it is only to preserve, for example, the water resources, which could enter into a critical state; it's as simple as that. There is more at stake than just material wellbeing: the quality of life, something that is still not taken into account when the Gross Domestic Product is calculated.

Menorca has another very important source of wealth. It is that formed by all those who today maintain, against wind and tide,

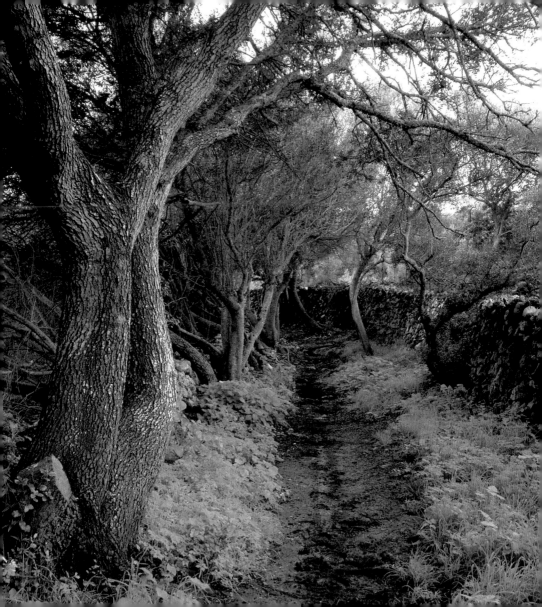

a large part of the social capital present on the island, who work so that its inhabitants can feel that they are "from Menorca". They are the economic players who, with their daily activity, preserve the economic potential of a sustainable model; who generate industry, recurrent activity that revitalises, replace capital, secure expert training, who take risks, who work hard and do not give up when faced with difficulties, who confront the open markets not as a focus or as threats but as a source of opportunities, along with workers who are committed to doing their jobs well, and who in their companies are prepared "to take the rough with the smooth". Groups which revitalise civil associations are also present in the recreation and leisure field; groups that develop collective activity, who share projects and who turn public participation into a service for those that need it most. All those who are always ready to provide a response to the emerging problems of our society: the social volunteer, these people who dedicate their free time to help the little ones in their school tasks, who cooperate in our schools; the groups that work with people who find themselves in difficult circumstances, those that takein immigrants and mobilise against poverty and marginalisation ... They are those who, silently, sustain the island's social capital.

Finally, regarding the Catalan language –the language of the Menorcans, and probably their main sign of identity–, its state of health must be measured by its use amo ng the people. According to recent sociolinguistic data, the situation is better than on the islands of Mallorca and Ibiza, both in the number of Catalan speakers and for their level of spoken and written knowledge; although this should not leave any room for self-complacency. The population of Menorca, it must be said, represents only 0.7% of the current total of Catalan speakers, but neither the smallness of the territory nor its small number of inhabitants reduces the importance of a people with its own personality.

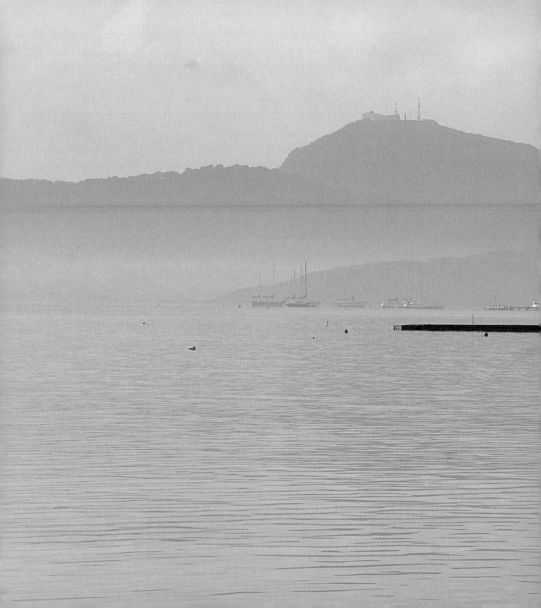

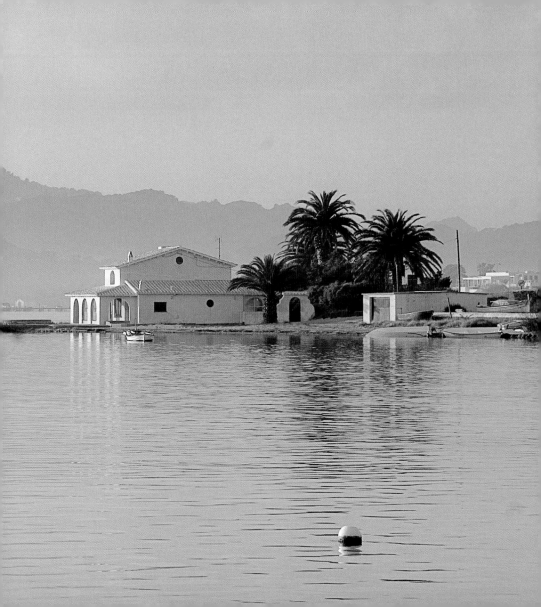

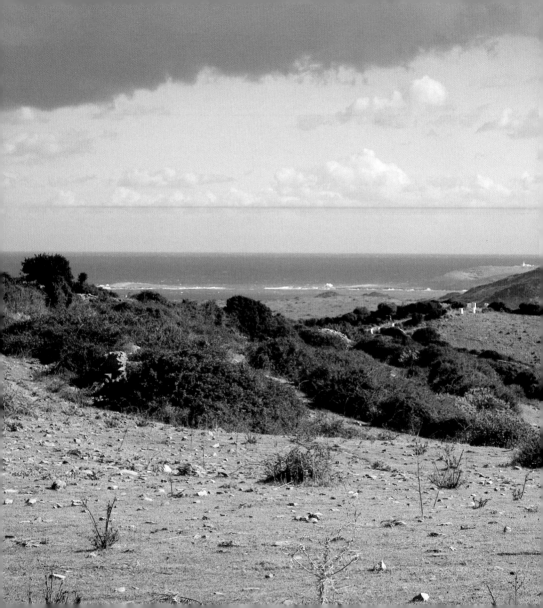

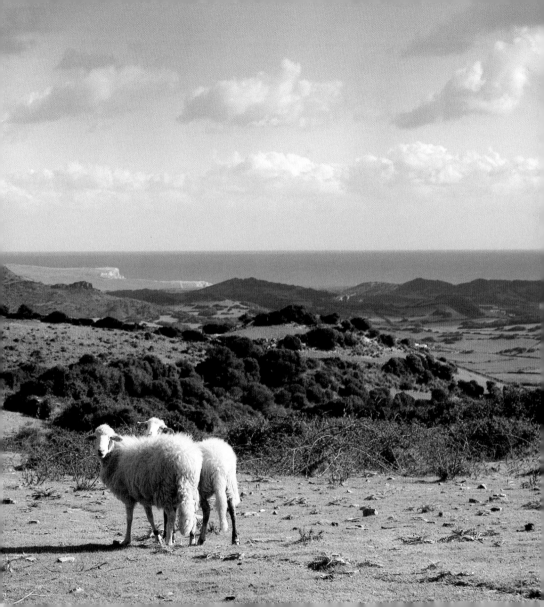

© **2007, TRIANGLE POSTALS, SL**

Photographs **JAUME SERRAT:** 18, 28, 35, 38, 40, 42, 43, 55, 56, 57, 58, 73, 85, 88, 90, 91, 92, 94, 95, 97, 100, 101, 102, 104, 105, 108, 109, 112, 122, 123, 127, 139, 155, 174, 176, 178, 182, 183, 184, 186, 189, 194, 195, 216, 217, 232 **JUANJO PONS:** 1, 2, 3, 8, 22, 27, 30, 32, 36, 39, 68, 70, 71, 78, 82, 84, 86, 98, 99, 116, 120, 124, 125, 134, 135, 144, 146, 147, 148, 151, 156, 159, 160, 161, 163, 180, 181, 185, 188, 193, 201, 212, 234, 236, 238
RICARD PLA: 12, 14, 24, 33, 45, 46, 79, 83, 110, 138, 157, 162, 164, 165, 166, 171, 172, 173, 190, 196, 197, 204, 206, 213, 223, 224, 226, 228 **JORDI ESCANDELL:** 4, 10, 20, 37, 50, 51, 52, 62, 72, 74, 80, 103, 130, 145, 152, 170, 177, 192, 202, 203, 215
LAIA MORENO: 128, 129, 133, 136, 137, 140, 141, 142, 143, 167, 208, 209
SEBASTIÀ TORRENS: 16, 48, 49, 53, 59, 65, 66, 67, 75, 76, 77, 93
XAVIER CARRERAS: 132, 150, 154, 158, 168, 175, 198, 200, 211, 230
LLUÍS BERTRAN: 118, 207, 210, 214, 218, 219, 220, 221, 222
FRANCIS ABBOT: 34, 106, 107, 126 **ISOLDA DELGADO:** 87, 96 **JOAN PETRUS:** 6, 44, 54, 60 **CARMEN VILA:** 64, 187 **ORIOL ALEU:** 131 **MANOLO SOSA:** 63

Text **JOAN F. LÓPEZ CASASNOVAS**

Translation **STEVE CEDAR**

Coordination **JOAN MONTSERRAT**

Design **JAMES KOCKELBERGH**

Printed by **NG NIVELL GRÀFIC**

Reg. number B-29433-2007

ISBN 978-84-8478-264-3

TRIANGLE POSTALS, SL

Carrer Pere Tudurí, 8
07710 Sant Lluís, Menorca
Tel. +34 971 150 451 / +34 932 187 7 37
Fax +34 971 151 836
www.trianglepostals.com